A–Z

OF

EASTBOURNE

PLACES - PEOPLE - HISTORY

Kevin Gordon

AMBERLEY

First published 2019

Amberley Publishing
The Hill, Stroud, Gloucestershire, GL5 4EP
www.amberley-books.com

Copyright © Kevin Gordon, 2019

The right of Kevin Gordon to be identified as
the Author of this work has been asserted in
accordance with the Copyrights, Designs and
Patents Act 1988.

ISBN 978 1 4456 9045 2 (print)
ISBN 978 1 4456 9046 9 (ebook)

British Library Cataloguing in Publication Data.
A catalogue record for this book is available
from the British Library.

Typesetting by Aura Technology and Software
Services, India. Printed in Great Britain.

Contents

Carpet Gardens.

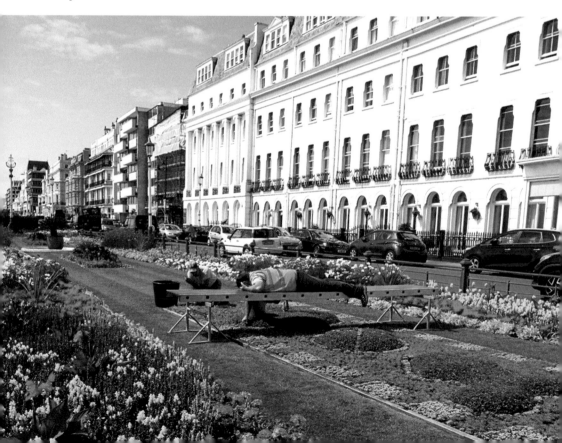

Introduction

The idea of an 'Eastbourne ABC' was considered over 100 years ago when an 'Eastbourne Alphabet' was published as a postcard, probably in around 1915 (see below). Some of the letters need some explanation. In 1911, Eastbourne Council passed a by-law that forbade dogs from barking on the beach – that explains 'D for Doggie'. 'L' relates to the Sunday post-church parades held on the Western Lawns near the Grand Hotel. Ladies were keen to show off their finest 'Sunday best', and no doubt the 'powder and paint' relates to their makeup.

One letter I cannot fathom out is 'K', and would be fascinated to discover what it stood for. Let me know if you know!

I would dearly love to write an Eastbourne encyclopaedia, but fear that it would be a massive book and take decades to write. As such, this small tome is my personal 'ABC of Eastbourne', and I have tried to provide you with an entertaining, diverse alphabet that leads you from Arctic rolls to Zeppelins by way of Norway and urinals! It would be impossible to write the whole history of Eastbourne in this book and I acknowledge there are many omissions, but I hope you enjoy my small selection.

THE EASTBOURNE ALPHABET!

A is our AIR—to which some add an "S."
B 's BEACHY HEAD—if you fall, there's a mess!
C 's the CONDUCTOR, who *faces* the crowd.
D stands for DOGGIE, who daren't bark aloud.
E is the ELEGANT GIRLS we possess.
F is the FRONT, where they show off their dress.
G for the GIRLIES who shriek when they swim.
H for the HATS—quite a yard round the brim.
I 's the INHABITANTS—Gentile and Jew.
J is for JUMP—Drat that Motor Car Crew!
K 's for——ah! would you! it certainly aint.
L for the LAWNS—Oh! the powder and paint.
M 's MOTOR BUSES—how smoothly (?) they run.
N is for NOISE, of which there is none (?)
O h's for the Fireworks at Devonshire Park.
P 's for PARADISE—(the earthly one, mark).
Q the QUEER things which wash up on the beach.
R 's RESPECTABILITY, we practice *and* preach.
S is for SALARIES our officials are getting.
T 's for TOWN HALL where there isn't much sweating
U —very strange—stands for UP to the *Downs*!
V is the VISITORS, all smiles and no frowns.
W for WISH TOWER—to wish is *quite* free.
X Many of 'em, he writes home to she.
Y means the YACHTS we all own—so we swear.
Z stands for ZENITH and EASTBOURNE is there!

A.J.C.

276

Eastbourne ABC postcard.

Air Raids

At the outset of the Second World War hundreds of women and children were evacuated from London to Eastbourne, which was thought to be an unlikely target for the Luftwaffe. Eastbourne, however, suffered its first bombing raid at 11 a.m. on the Sunday morning of 7 July 1940, when a solitary German bomber circled the town, dodging anti-aircraft fire. It attacked from the direction of Willingdon and dropped bombs in Whitley Road, destroying several houses and badly damaging many more. Two elderly men were killed and Birchfields store, on the corner of Whitley Road and Clarence Road, was destroyed.

This first attack was witnessed by a very naughty boy: eleven-year-old Roger Gordon of Annington Road – my dad. My grandmother, Bessie, was getting annoyed that morning

Below left: Eastbourne's first air raid.

Below right: Roger Gordon, who witnessed the first air raid.

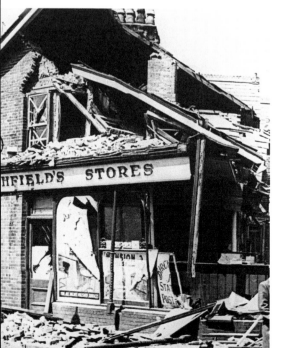

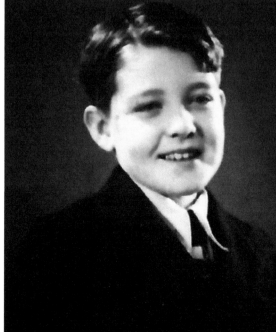

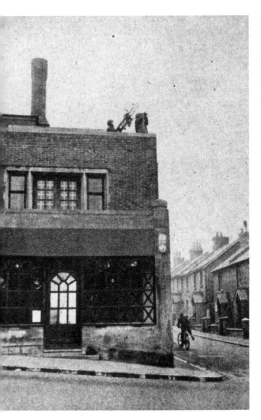

AA gun on the Tally-Ho.

because my father had not got himself ready to go for a walk, which would have taken them from their home along Whitley Road, past Birchfields shop to Seaside. When the bombs dropped the windows of their home were broken and the walls cracked. My father remembers the devastating scene outside their house. The family ran under the stairs for safety, but my dad's naughty behaviour undoubtedly saved them from injury or worse.

After this raid the evacuees returned to London and Eastbourne children found themselves being evacuated. Anti-aircraft guns were dotted all over the town, including one on the golf course and another on the roof of the Tally-Ho pub in Old Town. There were four massive guns in Princes Park, with the crew living in tents nearby.

Eastbourne was subject to more air raids than most south coast towns. There were over 2,000 air-raid warnings. A total of 671 high-explosive bombs and over 4,000 incendiary bombs dropped on the town. Towards the end of the war, fifteen V-1s (doodlebugs) landed in Eastbourne and the local ARP had to deal with ninety unexploded bombs and twenty-one mines that were washed ashore.

Many civilians were killed during the air raids, and in 2018 a memorial stone to remember them was unveiled at the Wish Tower.

Princess Alice

Princess Alice was the second daughter of Queen Victoria. In some photographs she looks remarkably like her mother; however, unlike the queen, she was a patron of women's causes and had an interest in nursing. She followed the work of Florence Nightingale and nursed her father, Albert, in his final years. In 1862, Alice married Prince Louis of Hesse at Osbourne House on the Isle of Wight. The ceremony was described by the queen as being 'more like a funeral than a wedding' and it was an omen of an unhappy marriage, despite the couple having seven children.

The family lived in Germany, but when they visited England in July 1878 they lodged in Eastbourne, taking a suite at High Cliff House on Grand Parade. They stayed for a few days and amused themselves by roller skating at Devonshire Park and visiting the nearby Pavilion (see page 43) to watch a performance by the Eastbourne Dramatic Club.

Eastbourne people were very proud of the princess, who, unlike her mother, seemed to have an easy way with ordinary people. She attended a prize giving at Eastbourne College and inspected the Eastbourne Steam Fire Brigade. Her nursing interest took her to All Saints Hospital at Meads, and she was keen to enter every room and speak to everyone she met. She sat on the bed of an elderly Irish woman and read to her and even took time to plump up the pillow of a 'poor cripple child'. It was said that she 'won the hearts' of everyone she met, and one cannot help seeing parallels with a later 'Princess of Hearts' – Diana.

Princess Alice Hospital.

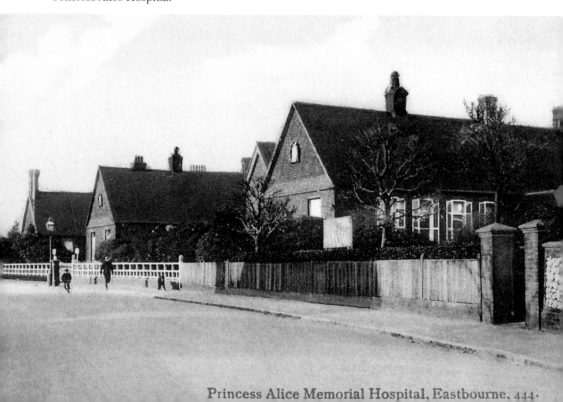

Princess Alice Memorial Hospital, Eastbourne. 444.

It is clear Alice and her husband really enjoyed their stay in Eastbourne, as they returned just a few weeks later. This time they opened a bazaar at All Saints Church, visited Christ Church School and attended a meeting of the Eastbourne Athletic Sports Club. While in Eastbourne she must have arranged for the chimneys of her lodgings to be cleaned as a local sweep, Mr J. Howard, proudly advertised his service as 'By appointment to HRH Princess Alice!'

The royal couple left Eastbourne for Germany where Alice soon became ill with diphtheria. She died in December that same year. The obituary in *The Times* noted that 'the humblest of people felt they had a kinship with the princess' and noted that 'Moral worth is far more important than high position'. The people of Eastbourne were understandably upset, and the council discussed a suitable memorial. Councillor Diplock suggested 'a memorial accident ward' at All Saints Hospital. (At that time there were no emergency medical facilities in the town and patients had to endure an often-painful trip to the County Hospital in Brighton by train.) A memorial dispensary was also mooted, but why have a ward or a dispensary when you can build a hospital? In April 1879, a public meeting was held at Devonshire Park with the proposal to raise funds for a 'Princess Alice Memorial Hospital'. The hospital was opened in July 1883 by the Prince of Wales (later Edward VII), his wife and Alice's daughter – Princess Elisabeth of Hesse. The hospital had just a few beds originally, but it soon expanded to become the emergency hospital that Eastbourne needed.

All Saints

All Saints Convalescent Hospital in Meads is a wonderful example of Victorian Gothic architecture and was one of the first purpose-built convalescent hospitals in the

All Saints Hospital.

country. The hospital was built for the All Saints Sisters of the Poor, established in London in 1851. It was built between 1867 and 1869 and a splendid chapel was added in 1874. During the First World War the hospital became the 14th Canadian Military Hospital with a large range of medical facilities including an operating theatre, but this did not prevent dozens of young Canadian recruits dying there during the flu pandemic of 1918 and 1919. The building has now been converted into luxury flats.

All Souls

All Souls Church in Susans Road is a striking Victorian church constructed of contrasting red and cream bricks. It was built in a Byzantine style with a detached campanile that is 16 metres (51 feet) high. It was consecrated in 1882 and funded by Lady Victoria Wellesley, the great-niece of the Duke of Wellington.

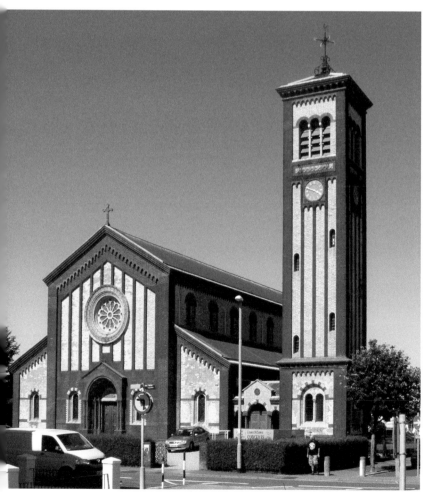

All Souls.

Arctic Roll

The roundabout near Tesco, at the junction of Lottbridge Drove and Seaside, is still known by many as the 'Birds Eye Roundabout'. Between 1967 and 1983 this was the site of a huge Birds Eye factory, once the largest employer in the town. The most enduring Birds Eye product made in Eastbourne was their Arctic roll. This ice-cream and sponge desert was first produced in Eastbourne by Dr Ernest Veldon, an immigrant from Czechoslovakia, and literally hundreds of miles of Arctic roll were made here. In the mid-1980s it was reported that 25 miles of Arctic roll made in Eastbourne were being sold every month!

Birds Eye factory.

Bandstand

The original Central Bandstand was built on stilts on the beach adjacent to Devonshire Place in 1884 and was quickly nicknamed 'the Birdcage'. The present bandstand was opened on 5 August 1935 and could accommodate 3,000 people. The bandstand has a memorial to local musician John Woodward. He was in the band of the ill-fated RMS *Titanic* and the memorial depicts the dramatic scene when the huge liner slipped under the icy waters of the north Atlantic. Today the bandstand is still a popular venue and hosts bands and tribute acts; indeed, it is claimed to be one of the busiest bandstands in the world.

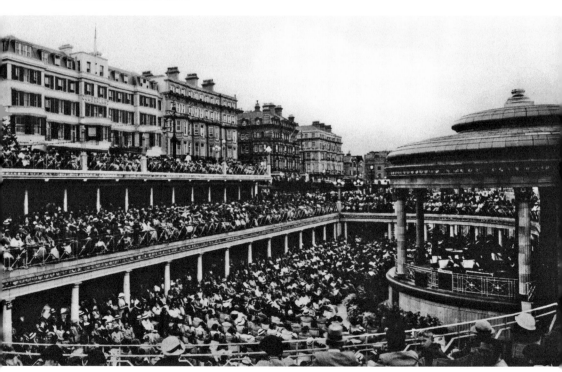

The Central Bandstand.

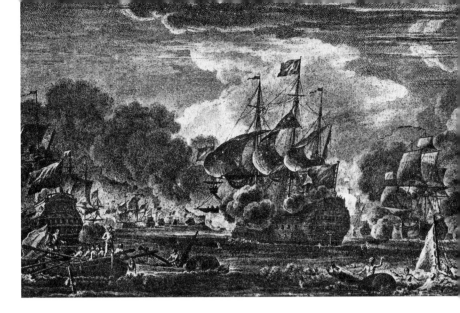

The Battle of Beachy Head.

Battle of Beachy Head

The Battle of Beachy Head was an engagement between French and English ships during the Nine Years' War, with Dutch ships supporting the Royal Navy. The battle on 10 July 1690 is known by the French as Bataille du Cap Beveziers, and they were the victors. We lost around ten ships, but the French lost none. The defeat created panic across England, leading to fears of a French invasion. One souvenir of the battle can still be seen locally: the figurehead from a damaged Dutch warship was found floating in the River Cuckmere and was attached to the side of the Star Inn in Alfriston, where it can still be seen today.

Beachy Head

The famous chalk headland of Beachy Head marks the eastern end of the South Downs and affords splendid views along the Sussex coast. Its name derives from the Old French *beau chef*, meaning 'beautiful headland'. At over 60 metres (500 feet) high, it protects Eastbourne from the westerly winds that give the town its balmy climate. This, in turn, allowed Eastbourne to develop as a resort.

The sea around Beachy Head was, and still is, treacherous, so in 1831 Belle Tout Lighthouse was built for Sussex MP 'Mad Jack' Fuller. When it was found that the light was often obscured during cloudy weather, a new lighthouse was built in 1902. The iconic lighthouse at the foot of the cliffs is 43 metres (141 feet) high and its lantern could be seen up to 48 kilometres (30 miles) away. It was manned until 1983, and in 2010 the fog signal was discontinued. In 2011, the light range was shortened when LED lights were fitted, but in June 2019 Trinity House said that the facilities would be enhanced when the *Royal Sovereign* lightship was decommissioned.

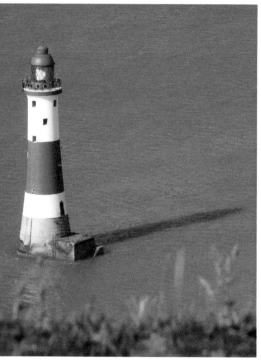

Above: Beachy Head.

Left: Beachy Head Lighthouse.

Black Hole of Calcutta

The Black Hole was a small prison cell in Calcutta (now Kolkata). When troops loyal to the Nawab of Bengal over-ran Fort William in the city in June 1756, prisoners of war, many of them soldiers of the East India Company, were captured. A total of 146 men were crammed into one prison cell, and in the sweltering heat all but twenty-three of them suffocated. One of the survivors was Henry Lushington, an interpreter for Major General Robert Clive (Clive of India) and son of the vicar of Eastbourne. He was

Henry Lushington.

killed in India in 1763 while being held as a prisoner of war again. A large memorial to him can be seen in the south aisle of St Marys Church. Under the bust of this man with an 'amiable and sweet disposition' is a full account of his life (and death).

The Blind Busker

James Collins was Irish. On 15 February 1861, when he was twenty years old, he was blinded by a shooting accident in Newry. He travelled to England and toured the country as an entertainer for several years. In Leicester he met Mary, the daughter of a Baptist minister, and they were married.

The couple arrived in Eastbourne in May 1880 and settled at No. 1 Gilbert Road. James found a pitch on the seafront near the Wish Tower slopes, close to where the Lifeboat House stands today. He was assisted by his dog, a spaniel called Rosie, whom he had rescued from Battersea Dogs Home.

James played a variety of Scottish and Irish songs on his violin including 'Bonnie Annie Laurie' and 'The Devil's Away with the Exciseman'. James entertained the seaside bathers, who could hear his music when they used the many bathing machines nearby.

George du Maurier was a talented Victorian cartoonist on the staff of *Punch* magazine. His most famous cartoon was the 'Curates Egg', which has become a part of the English language. George was a friend of the author Henry James and the grandfather of Daphne du Maurier. George visited Eastbourne in 1888 with a friend who was a talented musician. They passed the blind busker on a morning stroll and were disappointed that he was being ignored by the passing public. George's friend took James's fiddle and played it, gathering a considerable amount of loose change.

George and James became unlikely friends and George drew the 'Blind Fiddler' for a cartoon that appeared in *Punch*. The cartoon, entitled 'The End of the Season', shows the blind man playing to an empty promenade.

The Blind Busker.

In 1893 the mayor ordered the Eastbourne Police to remove entertainers from the seafront; however, it appears that 'the Blind Fiddler', as he had now been dubbed, had a friend in the council in the form of Alderman W. E. Morrison, who was lenient towards the Irish beach busker.

But life was not easy for James, and in March 1899 he wrote to the *Eastbourne Gazette*, complaining that his wife had been ill for two weeks but his blindness hindered proper care of her. He thanked the local doctor for attending to her free of charge, saying that if the doctor sent a bill it 'would be as long as the Atlantic Cable'. The doctor had prescribed brandy, eggs, milk and beef-tea, but he was too poor to pay. He had asked the Parish Relieving Officers to allow her to be admitted to a local hospital, but they had refused.

In May 1900, James attended the Eastbourne Magistrates' Court to complain about a man, 'Fred', who was abusing him and claiming that his blindness was a sham. James reported that he worked until 7 p.m. each evening and on average received around 2s a day. The magistrates' clerk said he would deal with the matter.

The following year, in 1901, James suffered two losses: his faithful dog Rosie died, shortly followed by his wife, who died of bronchitis. James played a lament at her graveside. James was helped by his church, who found a home for him in Bexhill called Nazareth House. He later moved to Tunbridge Wells where he died.

Bourne Stream

The pond in Motcombe Gardens is protected by a statue of Neptune, who also marks the source of the Bourne Stream, which gave Eastbourne its name. It slips underground near the bowling green, but can still be heard flowing under Ocklynge Road. The Star Brewery once obtained its water supply from the stream. It next emerges behind houses in the Goffs where it once fed a long-gone millpond. The stream then ran alongside Southfields Road (which was once Water or Watery Lane) to a pond to the rear of the Vestry Hall in Grove Road. This was used to fill the tanks

Neptune at the source of the Bourne Stream.

of the fire-engine which was based here. The stream once flowed along Ashford Road by the railway station and into a pond near to where the Leaf Hall now stands, but today it emerges briefly at Moy Avenue before flowing underground into the pond at Princes Park and then into the sea.

Burlington Hotel

Built in 1851, the Burlington was the first large hotel on the seafront. It was named after the 2nd Earl of Burlington (later the 7th Duke of Devonshire). The four-storey

Burlington Hotel.

building has iron balconies overlooking the sea and, according to the latest edition of the *Pevsner Architectural Guide*, 'is the only part of the seafront to stand up to Brighton's Regency grandeur'.

Bus Service

Eastbourne bus service was the first municipal bus service in the world, earning it a place in the *Guinness Book of Records*. The first service ran from the railway station to Meads on 12 April 1903. It was popular and soon routes were serving the whole town. The original buses were Miles Daimler 16-horsepower double-deckers, which could accommodate thirty-two passengers. The last horse-drawn Eastbourne bus was withdrawn a few months later in August. The bus shelter at the junction of Seaside and Whitley Road is probably one of the oldest in the country and is now a listed building. Eastbourne Buses ran until 2008 when the company was acquired by Stagecoach, who now run local routes.

An early Eastbourne bus.

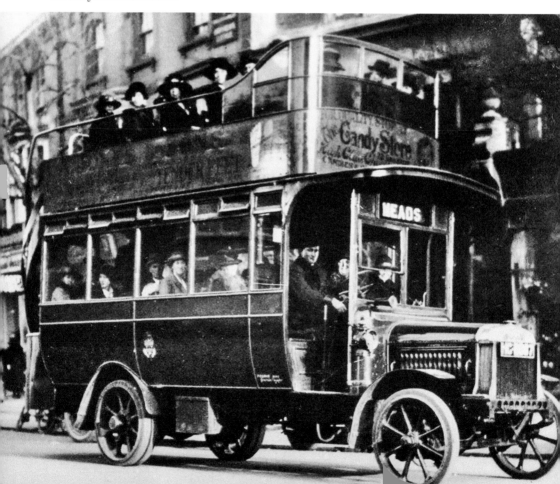

C

Caffyn's

William Morris Caffyn opened a shop at the east end of Meads Road on 19 May 1865. He was a gas-lamp manufacturer and in 1868 successfully got a contract from the council's lighting committee to maintain the town's streetlamps (new lampposts would cost £3 14s each and repairs would be 5s)

In 1871, William moved his business to No. 43 Seaside. His adverts showed him to be a gas engineer, bath and hot water fitter, lamp maker, brass finisher and bell hanger. His sons Percy and Harry also joined the business. At the turn of the century the focus of the company moved from gas to electricity and an electrical appliance shop was opened at No. 1 Church Street in Old Town. As well as lights, electric bells and telephones were also sold and installed.

In 1901, the theatre opened at the end of Eastbourne Pier and this was lit by electric lights installed by Caffyn's. The footlights were electric, and electric lights shone from the mouths of bearded masks on the walls. Hanging from the ceiling were ten electroliers (chandeliers lit by electricity).

Caffyn's were obviously keen to be at the forefront of modern innovations (in 1903 they were selling an egg-testing machine!), but it was the new-fangled motor car

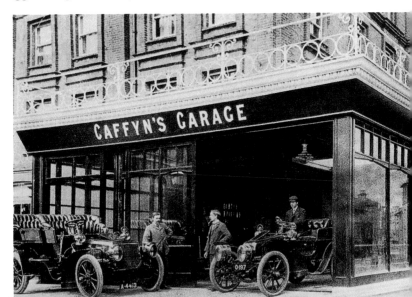

Caffyn's Garage.

that was to change their business forever. Around this time, a visitor to Eastbourne wanted somewhere to safely store his car away from the seafront and the Caffyn boys agreed to look after it at their shop. Later the Queens Hotel asked them to look after the motor cars of their visitors. The brothers decided that the motor industry was the way forward and bought out their father to become Caffyn Brothers. They purchased No. 12 The Colonnade (at the back of the Queens Hotel) to store and repair four motor cars. It is interesting that at the time they referred to the premises as a 'coach house' and the cars were 'stabled' there.

In 1904, the property was enlarged to hold sixteen cars and the name 'Caffyn's Garage' was used. The brothers were keen to expand their business and in 1906 opened a garage at Marine Parade that could accommodate 100 cars. Their detractors predicted that they would go out of business as Eastbourne would never have 100 cars! How wrong they were. The company went from strength to strength and started to sell motor cars, employing a large number of local people as mechanics and salesmen.

In 1911, the company built their headquarters in Meads Road on the same site that W. H. Caffyn had opened his first shop many years earlier. They opened showrooms in Terminus Road (where WHSmith is today) and during the First World War even helped the war effort by producing aircraft parts.

Today Caffyn's has dealerships in towns across the south of England and has a turnover of millions, but it is still a family-run business with its roots firmly set in Eastbourne.

Camera Obscura

Camera obscuraa are an ancient method of projecting light and images onto a surface though a small aperture or pinhole. In September 1879, a camera obscura opened on the rising ground near Mr Earp's mansion, then known as The Cliffe. This site is now occupied by the Hydro Hotel. For a fee of tuppence, you could see the surrounding coast to a distance of around 14 miles on a clear day.

In June 1901, a new theatre was opened at the end of Eastbourne Pier and a camera obscura was installed above it. The obscura worked with a periscope that stuck up through the silver-topped dome and reflected an image onto a 6-foot-wide white table in the darkened room below. At the time it was the largest in the country – possibly in the world. The periscope was around 130 feet above the seabed and could be moved around to give a 360-degree view and was particularly effective in bright weather with fine views towards Beachy Head and inland to Willingdon.

It was a popular attraction and for many years was leased to William Augustus Pelly, a shipping agent who lived nearby in Cavendish Place. He became an expert in the device, but many of its secrets were lost when he died in the war. At the start of the war the Pier Company were given just 10 minutes' notice that it was to be requisitioned by the army; the camera obscura became an observation post and the

equipment was removed. The men posted there were lucky to survive when it was hit by machine gunfire from a low-flying German aircraft on a hit-and-run raid. During the raid the swivel top of the dome was shattered.

In 1952 it was decided to reopen the obscura, but this was not without problems as much of the equipment had been lost. Some of the lenses were found hidden behind slot machines and Dorothy Pelly returned some of the equipment that her father had taken home. After much trial and error, a suitable mirror was found and the attraction was reopened to the public, operated by William Wood, the pier 'Amusement Manager'. He seemed to enjoy the role and the images were sometimes so clear that on several occasions he was accused of projecting a film image onto the table. This was countered by sending a member of the audience down onto the pier to wave to the camera.

The early camera obscura with Mr Earp's house.

The camera obscura.

Camera obscura sign.

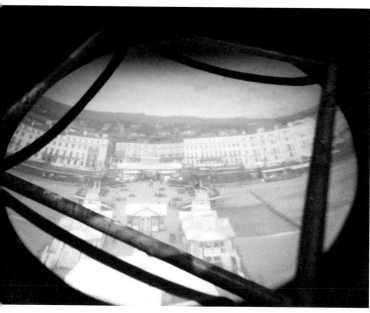

Camera obscura view.

The camera obscura was closed during the winter of 1956/7 for repairs, but remained a popular attraction until the disastrous fire of January 1970. It reopened in 2003, but the sea air is not good for metal machinery and it seized up. I recently had the opportunity of visiting the camera obscura with the chief engineer for the pier, Paul Dixon, who hopes it can soon be restored and opened to the public again.

Carpet Gardens

Eastbourne's sultry summer climate makes it a good place for growing flowers and the Carpet Gardens, near the pier, have been a popular attraction for over a century.

This display of flowers has always been a showcase for the skills of the council gardeners. A letter to the local paper in 1887 praises the 'carpet gardening' near the Wish Tower, saying that the planting was comparable with displays in London. The famous Carpets Gardens on the parade were first laid down in the late 1890s and

The Carpet Gardens.

included intricate and patriotic designs. In 1896, flowers were arranged to form the Prince of Wales feathers with the motto '*Ich Dien*' underneath. From that year the gardens were a regular feature of packets of 'Pictorial Views of Eastbourne' and later postcards, which were popular with the visitors.

The Boer War prompted the gardeners to create designs including the Union Flag and the text 'The colours that do not run'. The designs included the letters 'VR' and the names of many of the generals of the South African war. In 1928 one councillor suggested that the Carpet Gardens be dug up to accommodate more traffic around the entrance to the pier, but this was fiercely opposed and in 1930 the gardens were enhanced by the addition of fountains, which were later lit by coloured lights. These provided colour not only all-year around, but even at night. Sadly, the fountains were removed in the 1990s, but the gardens continue to be a bright strip of colour on the seafront.

Cavendish Hotel

Work started on the Cavendish Hotel in March 1865, but it stood empty until July 1873. The hotel was named after William Cavendish, the 7th Duke of Devonshire, whose statue sits nearby. It originally had 100 rooms and for some reason separate coffee rooms for ladies and gentlemen. The hotel is in a prime position opposite the Central Bandstand on the corner of Devonshire Place, which at one time was going to be a grand boulevard connecting the railway station to the sea.

The hotel was modernised in 1930, but closed for visitors when it was requisitioned by the military in 1940. On 4 May 1942 a 250-kg bomb destroyed the east wing, which was rebuilt in 1965 in a more modern style. One permanent resident in the 1950s was Convict, the hotel dog. He was a retired military police dog and had served in North Africa during the war; he was a favourite with both staff and residents.

Cavendish Hotel.

Compton Place

Originally Bourne Place, this grand stately home was built in the early seventeenth century, but was rebuilt in the 1720s for Spencer Compton, 1st Earl of Willingdon. It has been remodelled on several occasions, but, despite being used as a language school since the 1950s, retains many original features and, apart from the Church, is the only Grade I listed building in the town. The blue and white plasterwork throughout is particularly fine. The building later became the seaside home of the dukes of Devonshire and on several occasions hosted members of the royal family, including our current queen.

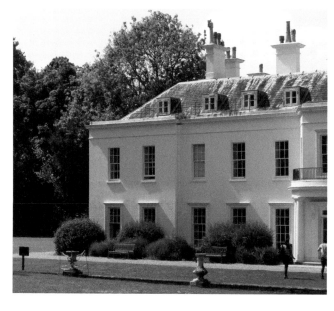

Compton Place.

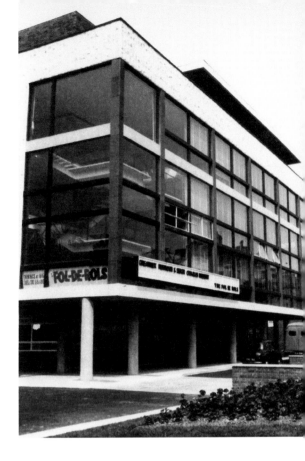

Congress Theatre.

Congress Theatre

The Congress Theatre was built in Devonshire Park on the site of the old Indian Pavilion (see page 43). It was opened on 13 June 1963 for a concert by the London Philharmonic Orchestra. It has a capacity of over 1,500 and has a Grade II* listing. For many years the theatre hosted the *Fol De Rols*, a popular music hall show that toured the UK between 1911 and 1976. The theatre has recently been renovated and reopened in 2019 as part of the Devonshire Quarter.

Tommy Cooper

The madcap comedian married a local girl, Gwendoline Henty, who he called Dove. They would regularly visit Eastbourne to stay with Gwen's parents in Mill Road, but later had a holiday home in Motcombe Road. This house is now marked with a fez-topped metal silhouette. Tommy's drinking habits are reflected in that many people, particularly in Old Town, can tell stories of his exploits after visiting local pubs. Tommy, one of my favourite comedians, died on stage in 1984 and was cremated in London but his name appears on the Henty family grave at Ocklynge Cemetery. For many years Tommy's niece Sabrina ran a magic shop in Cornfield Road.

Devonshire Park Theatre

This 900-seat theatre was built in 1884 to a design by Henry Currey, who became the favoured architect of the Duke of Devonshire in the 1850s. The theatre had to compete against several other places of entertainment in Eastbourne and by the turn of the century was looking a bit forlorn. However, the house was packed on 19 November 1900 for a lecture by the newly elected MP for Oldham, a twenty-six-year-old Winston Churchill. The *Eastbourne Gazette* described him as slightly built, ruddy faced and with an abundance of hair – not the Churchill we remember today! Extra seats had been found and this persuaded the theatre director, Mr Standen Triggs, to commission the renowned theatre designer Frank Matcham to completely remodel the theatre. The rather dull exterior, squashed between two tall water towers, belies the splendid interior. As soon as you enter your eyes are lifted to the beautiful dome and the auditorium is no less spectacular. Whatever the production, a visit to the Devonshire Park Theatre is always a treat.

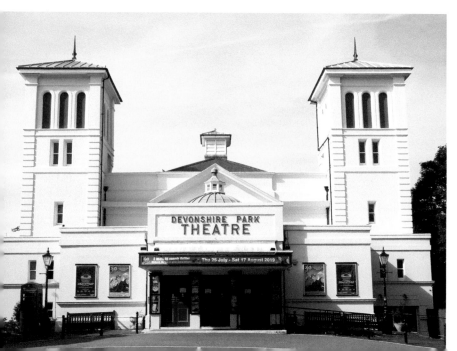

Devonshire
Park Theatre.

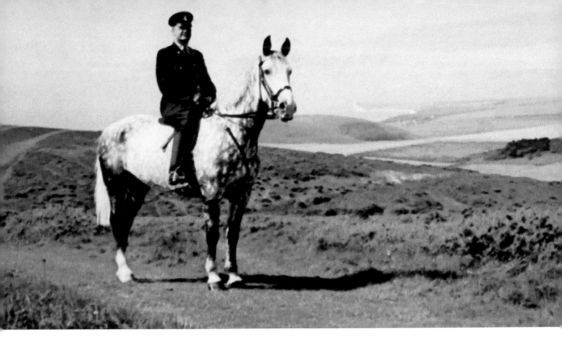

The Downs Ranger.

Downs Patrol

The Downs Patrol was the name given to the mounted Eastbourne borough policemen, whose beat was the countryside around the town. The first Downs Patrol started in 1926 shortly after Eastbourne Corporation purchased much of the surrounding South Downs; however, at this time it was a civilian role and patrols were made on foot. Officially the police started to patrol the Downs on horseback from 7 October 1929, although there is evidence of an earlier mounted patrol when a PC Pennington of the Eastbourne Borough Police Force occasionally used a horse stabled in Grange Road to patrol the Downs.

The first horses were lent to the police by the public. In April 1930 a horse was lent by Lieutenant Colonel Gwynne, and in 1940 a Mrs Ethel Webb lent the Eastbourne Watch Committee a noble horse called Mark for the use of PC Poole. Mark died six years later.

The Downs Patrol not only kept law and order by preventing trespassing and deterring illegal hunting, but was also able to report back to the council when fencing needed to be repaired. They also reported to the council when they saw fissures appear on the cliff edge. On 17 December 1932, PC Poole witnessed a light aircraft land on the Downs and questioned the pilot who was found not to have the relevant paperwork. The pilot was summonsed and appeared at Eastbourne Court, which was believed to have been the first occasion that Aviation Law was heard by Eastbourne magistrates.

The patrol was also able to assist unfortunate people who fell from the cliffs (not always unintentionally). In 1938, PC Poole climbed down the cliffs at Beachy Head to rescue a person who had fallen over the edge. She had fallen onto a ledge and he was able to rescue her. It should be noted that originally the patrol was only two days a week.

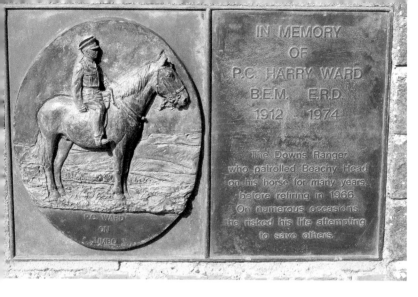

Downs Patrol plaque at Beachy Head.

The patrol was stepped up during the war with the assistance of the Home Guard. After the war the mounted patrol was put on a more permanent footing, with the horse now being 'police property' and a stable created near the Beachy Head Hotel. In 1955, Eastbourne had the only mounted police south of London. At this time the officer, now known as the 'Downs Ranger', was ex-serviceman PC Harry Ward whose mount was a chestnut horse named Princess Patricia. Harry was rewarded on a number of occasions for his bravery in descending the dangerous cliffs to try to rescue people and sometimes dogs who had fallen. He was a strong swimmer and entered diving competitions. He was once rewarded for saving a drowning child who had fallen into the oily waters of the pond near the gasworks. He later patrolled on a huge grey horse called Jumbo. PC Ward was awarded the BEM and the Emergency Reserve Decoration. Today a memorial to PC Ward and Jumbo can be seen on Beachy Head.

Another notable Downs Ranger was PC Jack Williams, who also patrolled on Jumbo. Jack joined the Eastbourne Police from the Royal Horse Guards in 1946 and would regularly ride into the town centre. I remember seeing him in Terminus Road when I was young. Like Harry, Jack was regularly awarded for his bravery during cliff rescues. Jack and Jumbo retired in 1973.

Dukes of Devonshire

William Cavendish (1808–91), 7th Duke of Devonshire, inherited large tracts of land in Eastbourne and his marriage to Elizabeth Compton of Compton Place (see page 24) landed him even more. He was an MP from 1829 to 1834 and succeeded Prince Albert as the chancellor of Cambridge University. The duke lived at Chatsworth House in Derbyshire and was lord lieutenant of the county for much of his adult life. He clearly enjoyed staying in Eastbourne and enthusiastically dedicated his fortune towards the development of the town. Many Eastbourne roads are named after his extended family or towns and villages in Derbyshire. His rather grumpy statue can be seen at the sea end of Devonshire Place.

Like his father, the 8th Duke, Spencer Cavendish (1833–1908), was also a Liberal politician and also used his considerable resources to the benefit of Eastbourne. He had a number of affairs (see page 73) and his rather lonely statue faces the Grand Hotel.

The current duke, Peregrine Cavendish, 12th Duke of Devonshire, still visits the town and is the patron of St Wilfrid's, a local hospice.

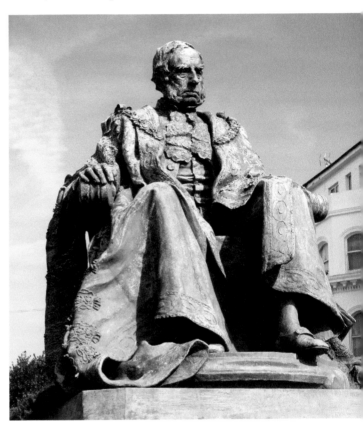

The 7th Duke.

The 8th Duke.

Eastbourne College

A meeting was called by local doctor Charles Christopher Hayman on 6 June 1865 with a view to 'the establishment of a proprietary college at Eastbourne for the education of the sons of noblemen and gentlemen'. Among the supporters were the local vicar, Revd Thomas Pitman, and the Duke of Devonshire, who offered land between Eastbourne and the village of Meads. It was the duke's architect, Henry Currey, who was later tasked with the design of the new school.

Revd James Russell Wood was selected to be the first headmaster and he moved from London to live at No. 1 Spencer Road. It was here that Eastbourne College opened on 20 August 1867. There were fifteen boys, who wore a uniform of black trousers without pockets, black jackets and a black tie. When outside they had to wear a straw boater with a ribbon of school colours (which seemed to be black!) The boys were forbidden from entering 'inns, taverns, billiard rooms and all places of public entertainment'. The school motto was chosen as *Ex Oriente Salus* – 'A place of safety in the east', possibly a pun on the name Eastbourne. Soon the school had nearly fifty boys.

The early years of the college were clearly difficult. There were disputes with the council and shareholders. When the council accused the headmaster of financial impropriety and appointed another (Revd Thompson Podmore), Revd Wood established a new school and took the teachers and most of the boys with him. With just five pupils and no school buildings, Podmore had an uphill struggle, but over the next few years the college slowly expanded. Classrooms were built and the college field was laid out. It was used for the first time on 22 July 1871 for a cricket match between the college boys and the Eastbourne Cricket Club. The following year the gymnasium and chapel were built.

A major part of school life was sport. There were several 'Fives' courts, which is similar to squash, only a fist (bunch of fives) is used rather than a racquet. There was cricket and athletics and the college had its own rowing club. Until 1870 Eastbourne College played 'Harrow Football' – a curious mixture of football and rugby. Even when they changed to rugby, a slightly different 'Eastbourne' version was played.

During the First World War over a thousand old boys and staff members served in the armed forces, and of these 174 lost their lives. Eastbourne College was proud of its

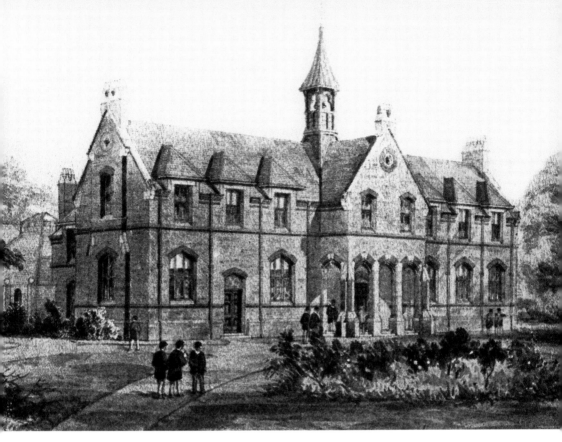

Above: Eastbourne College, 1871.

Below: Eastbourne College today.

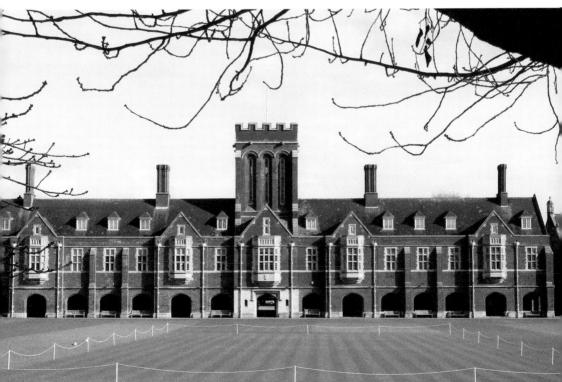

contribution to the war and in 1930 the striking War Memorial Building was opened. The college has researched the names of every boy on its roll of honour, which makes fascinating reading on the college website.

During the Second World War the college was evacuated to Oxfordshire, but on their return in 1945 the school steadily grew and there were over 400 boys by 1956. Girls were first admitted to the school in 1968. A massive fire in 1981 did not stop the steady progress of the college and today it is one of the leading colleges in the UK.

St Elisabeth's Church

At the time of writing, the massive St Elisabeth's Church is in a sorry state. It is closed and boarded up, awaiting demolition. Like St Bartholomew's Church in Brighton, it towers over the surrounding houses.

The church was built due to the generosity of Mrs Eliza Watson of Leahurst in Carlisle Road. Her endowment also paid for the church hall and the cost of the clergy. Revd H. Wallace Bird took the role. The foundation stone was laid by Princess Alice, Countess of Athlone, on 2 October 1935. The architect was Peter Stoneham, who also designed the Curzon Cinema in Langney Road and the rebuilt All Saints Church in Carlisle Road.

St Elisabeth's Church, 1937.

St Elisabeth's Church, 2019.

At the time of building during 1936 and 1937 the new church was described as a 'progressive modern building of noble proportions constructed of beautiful brickwork but unusually no east window'. St Elisabeth's had already been a growing and busy parish before the church was built. The church hall was not only used as a community centre but also a gymnasium, cinema and library. A council meeting in January 1937 was told that the parishioners were 'working class people who worked by digging and going up and down ladders all day rather than working in offices'. It was noticeable that children preferred to play in the hall rather than on the streets. One of those children was my mother, then Jean Sainsbury, who had a difficult childhood and remembers going to the church hall to get free pearl-barley soup, which was served from a large tapered enamel jug.

The new church on the brow of Victoria Drive was eventually consecrated on Saturday 19 February 1938 by the Bishop of Chichester. The church was very popular and within a few weeks over 400 children were attending Sunday school there. Civil-defence classes were held at the church at the beginning of the war, and during one subsequent air raid the church suffered severe blast damage.

Of particular interest were the paintings inside the church. Welshman Ernest Tristram (1882–1952) was responsible for paintings in the chancel. He is remembered today as the conservator for the Coronation Chair in Westminster Abbey. There were also a number of murals by Hans Feibusch (1898–1998), who had arrived in England a few years earlier to escape Nazi persecution.

At 140 feet tall, this large church needs no tower to impact on the townscape of Old Town, but in 2013 the church estimated that it would cost around £3.5 milliom to save. The parish of 'St Es', however, has not allowed the state of its church to prevent it being a centre of the community and the church hall happily hosts dozens of events each month.

Flying

Eastbourne Aerodrome operated from 1911 to 1921 on a site near the present Lottbridge Drove industrial estates. It was a flying school and the base for the Eastbourne Aviation Company. In 1912 a biplane from the aerodrome conducted an experiment to ascertain if submarines could be seen from the air. They used the submerged wreck of the SS *Oceana*, which had sunk 7 miles from Eastbourne earlier in the year (see page 72). The findings were vital to the war effort a few years later.

One of the first instructors was a young New Zealand pilot, Joel Hammond. He married a Seaford girl and was one of the first people to fly in Australia and New

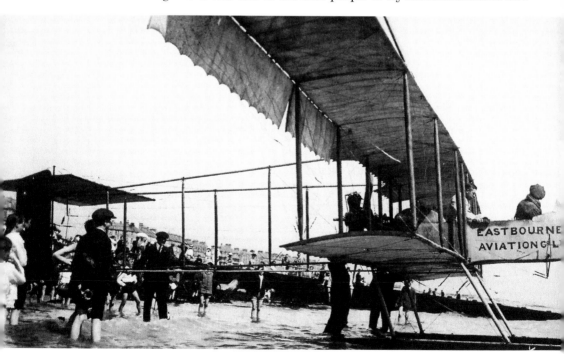

A seaplane.

Above: Advert.

Below: Flying exercise, 1912.

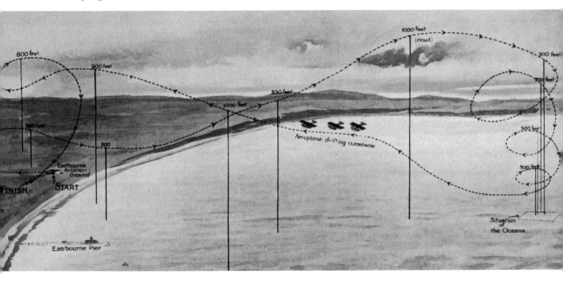

Zealand. During the First World War pilots came from all over the world to learn to fly at Eastbourne. One was Brazilian pilot Eugenio Possolo. He was killed during a crash at the airfield in 1918 and is buried at Ocklynge Cemetery. He was the first Brazilian to be killed in a flying accident and a road in Rio de Janeiro is named after him. The Eastbourne Aviation Company manufactured seaplanes, which could be hired from a beach to the east of the pier.

Football

Eastbourne Town FC was established at Devonshire Park in 1882 and is the oldest football club in Sussex. It now plays its home matches at the Saffrons Ground.

The 1st Sussex Royal Engineers Football Club were established in Eastbourne in 1894, using the Saffrons ground near the Town Hall for their home games. In 1901 they moved to Gildredge Park and shortly afterwards changed their name to the snappy 1st Home Counties Royal Engineers (Eastbourne) Football Club. After the First World War the team changed their name again to the Old Comrades, and one of their matches in 1920 against the Royal Corps of Signals was notable as the very first outside broadcast of a sporting event in England. The team became Eastbourne United in 1959 and now play at the Oval Ground at Princes Park. One notable Eastbourne United coach was Ron Greenwood, who left the club and went on to manage West Ham United and England.

In 1895, the Christ Church Football Club and the Band of Hope Football Club amalgamated to form the Eastbourne Evergreens FC (seen here in 1907). They seem to have played their last match in 1929.

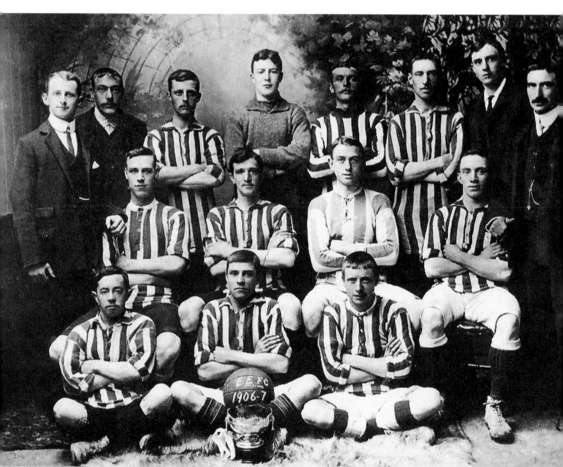

Eastbourne Evergreens FC.

G

Guy Fawkes

I love Bonfire Night. When I worked as a tour guide in the Houses of Parliament I regularly recited 'remember, remember the fifth of November...' while standing in the Princes Chamber, which is immediately above the cellars where Guy Fawkes was caught red-handed in 1605.

The Gunpowder Plot came within living memory – just fifty years – of the Marian Persecutions. During the reign of Queen Mary, seventeen Protestant martyrs were executed in front of the Star Inn, Lewes, just a few miles away. The people of England, but particularly Sussex, celebrated the arrest of the perpetrators of the 'Catholic Plot' by building bonfires topped by effigies, not only of Fawkes but also Pope Paul V – the pope of the time.

Bonfire Night celebrations gained popularity in the 1800s. Although Lewes has been the focus for Sussex celebrations, it should be remembered that, at this time, most towns and villages in Sussex had a firework display and many had bonfire societies. The Eastbourne Bonfire Society was formed in 1855, but each local parish held its own celebrations and had probably been burning Guy Fawkes effigies since the seventeenth century. A press report of 1858 assures readers that 'this year no fire-balls or dangerous missiles' would be used in the Eastbourne bonfire parade, which indicates that in previous years they were.

The headquarters of the society was the Marine Tavern in Seaside, and this was the starting point for their processions around the town. These were accompanied by the Saxhorn Band, blazing tar barrels, banners and effigies of Guy Fawkes and the pope. Later on, the society formed its own brass band. These parades were clearly anti-Catholic in nature, but 'enemies' who would be burnt in effigy extended to the Emperor of China, Irish Republicans and other people who had been in the news.

By the 1870s the society had gathered momentum and there were two long processions, which included dozens of banners and members carrying Roman candles and other fireworks. The leader of the society dressed as the Lord Bishop of Eastbourne, wearing a bishop's mitre and robes. The bonfire site at this time was on the slopes leading up to the Wish Tower.

In the 1880s and 1890s the Eastbourne group merged with other societies around the town and their parades became even bigger.

In 1891 the Eastbourne bonfire boys wore a diverse array of costumes, many of them 'blacking up' to represent Africans and Indians. One man was enveloped in green to represent the pagan Green Man and carried a large arch made of evergreens, which almost reached the ground. Another bonfire boy wore a large white hat, a black mask, black coat and checkerboard trousers, who added to the noise of the night by using a large old policeman's rattle. Yet another wore a black robe and a golden conical hat. There were also 'tourists' carrying fake cameras and 'tatterdemalions' (I had to look this word up – it means a person dressed in rags). Eastbourne was also one of the few bonfire processions that included women. They dressed as schoolgirls, clowns and several dressed as men.

My great-grandfather, Ebenezer Roberts, was a staunch Protestant and a committed bonfire boy. He was a member of the St Mary's Bonfire Society and by the 1880s had become their leader. Dressed in a lawyer's gown and wig, he would lead the Eastbourne Bonfire Boys through the streets to Paradise Road where a huge bonfire had been constructed. Every year he would climb atop a wagon and call the crowds to order before delivering his speech. I am lucky to still have his original bonfire speeches from the late 1890s, and he certainly let his bigotry about the Catholic Church be known. Today I suspect he would be arrested!

Ebenezer Roberts with the Bonfire Society.

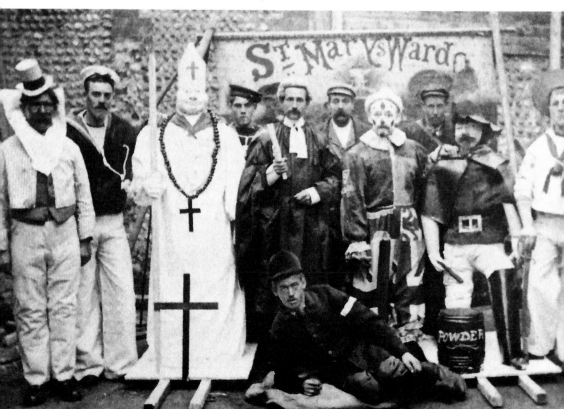

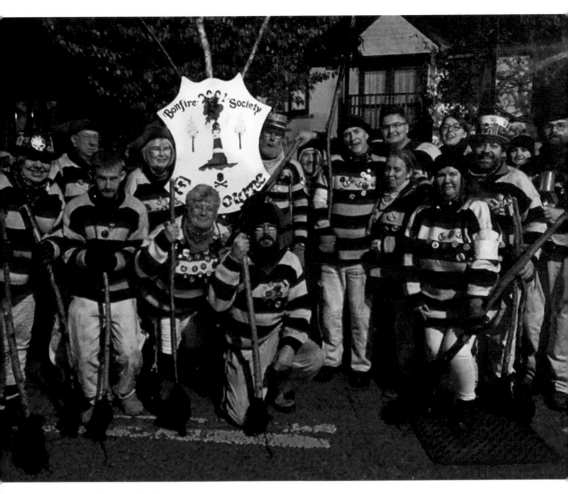

Eastbourne Bonfire Society.

Bonfire societies across Sussex were affected by the First World War. DORA (the Defence of the Realm Act) forbade the lighting of bonfires or fireworks near the sea and dozens of seaside societies were disbanded.

Interest in the bonfire tradition was rekindled in the 1950s but with an emphasis on entertainment rather than religion; however, there was a drawback in 1966 when the treasurer of the Eastbourne society ran off with all the funds. The society was restarted in 2001 but it took a few years for various permissions to be granted to allow the society to march through the town. Eventually, in 2012 the society was allowed to march along the whole length of the seafront to the Wish Tower and to light a fire on the beach. I am pleased to report that I took part in this parade as a member of the Shags – the nickname of the Seaford Bonfire Society, which I helped to re-establish. Hundreds of people lined the route and the event went safely and was enjoyed by all. I have since joined the Eastbourne Bonfire Society – Ebenezer would be so pleased.

Hampden Park

Hampden Park was previously a small wood surrounding a pond and was the park for the Ratton Estate. Ratton was mentioned in the Domesday Book and the pond included a decoy from where hunters could shoot wildfowl. Lord Willingdon sold the estate to Eastbourne Corporation in 1901 on the condition that they improve the road between Eastbourne and Willingdon. The park was opened by former Prime Minister Rosebery in August 1902 and was named after Lord Willingdon's grandfather, Viscount Hampden. In May 1913, Lady Willingdon offered the council a lion cub for the park, but the Pleasure Grounds Committee declined the offer as 'a lion cub does not remain a cub forever!' Even without a lion, the park soon became a popular attraction and it is still a fine place to visit for a stroll.

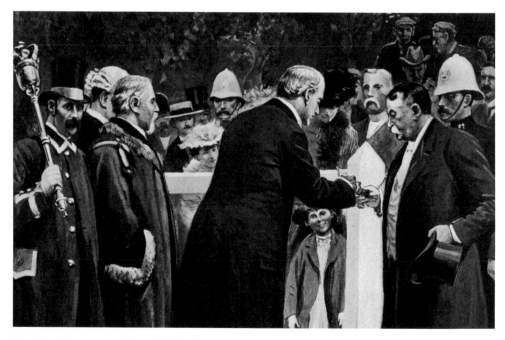

Lord Rosebery opens Hampden Park.

Revd Victor Hellaby

When Revd V. R. D. Hellaby died in Seaford in 1995 there was a brief obituary in the *Church Times*, but this unassuming cleric had a fascinating past as an actor, poet and prisoner of war.

Victor Hellaby was born on 19 October 1910. He started a career in commerce, but was always spiritual and also a member of the Territorial Army. He commanded the Eastbourne detachment of the 5th (Cinque Ports) Battalion of the Royal Sussex Regiment (Territorials).

At the outbreak of the Second World War, Victor found himself as a battery captain in the 57th Anti-Tank Regiment of the Royal Artillery. The regiment had been sent to Belgium to fight a rear-guard action against the advancing Nazis, but on 22 May 1940 he was wounded and later captured at Oudenarde, near Ghent. Victor was taken to a prison hospital in Holland. Here he recovered from his injuries before being sent to Oflag VIIb, a prisoner-of-war camp at Eichstatt in deepest Germany, situated in a forest around halfway between Nuremburg and Munich.

It is difficult to imagine today what the conditions were like in this camp. Captain Hellaby was there for five long years. The camp commandant imposed a strict regime and at one point two RAF officers were shot dead when they were found out of their hut five minutes after a curfew. There were long periods of sheer boredom when the men entertained themselves as best they could by holding concert parties and dances. Captain Hellaby wrote poetry and took part in some of the camp entertainments and at one time took the role of Polonius in Shakespeares *Hamlet*. Costumes and makeup for the production were supplied by the Munich Opera House and the production was enjoyed by the prisoners and local people, who were permitted to attend.

During his incarceration, Captain Hellaby was in correspondence with Dr George Bell, the Bishop of Chichester, who sent him theological books and urged him to take the cloth on his release. Hellaby's poetry expressed his deep religious beliefs and the sadness in being parted from his wife, Marjorie. In one of his poems he writes, 'The fall is here again, the trees and gold, and every day I think of you a thousand-fold'.

When he was finally released in May 1945 he returned home to live in North Avenue, Old Town. He was ordained as a deacon at the nearby St Elisabeth's Church in Victoria Drive in September 1946. This was the very first Church of England ordination to be held in Eastbourne.

Although he spent a short time as the chaplain to a school in Redhill and as a vicar in South London, he spent the rest of his life in Sussex. Between 1955 and 1962 Victor was the vicar of St Andrew's Church, Norway, in the east end of Eastbourne. The *Church Times* described him as being outspoken and sometimes tempestuous but with a spiritual insight and a great sense of humour. He also retained an interest in the military and at one time was the chaplain to the Inns of Court Regiment.

Upon his retirement in 1982, Father Victor moved to Seaford and attended St Peter's Church in East Blatchington. When the vicar there retired the following year, he served the parish for nine months before a new priest was appointed. He then became

an honorary assistant priest and helped with services, travelling around the parish and visiting those who were unable to attend church.

Revd Victor Hellaby died in January 1995 but is still remembered with affection in Eastbourne and Seaford.

Hippodrome

The Royal Hippodrome Theatre in Seaside Road was opened on 2 August 1883. The architect was Charles Phipps (1835–97), who also designed the Theatre Royal in Brighton and several London theatres; indeed, the Hippodrome was partly modelled on the Savoy Theatre. When the chairman of the Eastbourne magistrates granted the theatre its licence, he made it clear that he hoped it would be a legitimate home of drama and not degenerate into anything of the 'music-hall type'.

When the theatre was refitted and reopened on 31 October 1904, it did indeed become a music hall and hosted many famous variety acts, including Harry Houdini, Marie Lloyd, Charlie Chaplin and Fred Karno's Circus. It packed in the audiences with two shows every night. Between the wars the shows included radio stars such as Flanagan & Allan and Max Miller

By the late 1950s television sales started to rise and theatre audiences declined. At one stage there were plans to convert the theatre into a television studio but instead it was purchased by Eastbourne Council. Since then acts such as Bruce Forsyth, Peter Sellers and Ken Dodd have graced the stage.

In 2019 the Royal Hippodrome received another refurbishment to keep it going well into the twenty-first century.

Hippodrome.

I

Indian Pavilion

The Royal Naval Exhibition was staged at Chelsea during the summer of 1891. There were several temporary buildings and one of them, the Peninsular and Oriental Pavilion, was purchased by the Duke of Devonshire to be re-erected in Devonshire Park the following year as the Indian Pavilion.

For many years the Pavilion hosted grand balls and dinners. The Pavilion could be hired out for meetings, exhibitions and entertainments. I was amused to read that in July 1894 it hosted Mazeppa, who could understand English, German and French. Mazeppa could tell the time and do complex calculations – given a person's age he could calculate their year of their birth. If you are not impressed, Mazeppa was a horse!

In 1958 the name of the Pavilion was changed to the Devonshire Lawns Restaurant. But the change of name did not improve its popularity and it was demolished to make way for the Congress Theatre in 1963.

The Indian Pavilion.

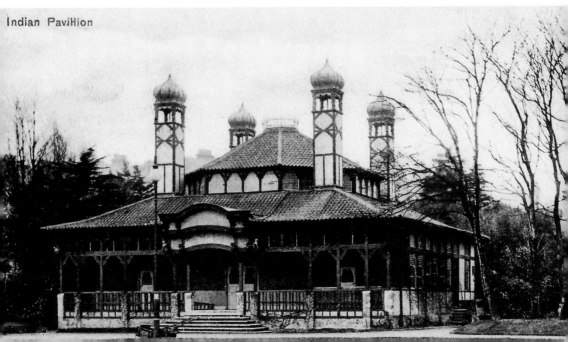

Indian Pavilion

Jack Brag

Theodore Hook (1788–1841) was an author, civil servant, practical joker and the sender of the world's first postcard. One of his literary creations was Jack Brag, a young chancer, gambler and braggart who travelled the country in order to escape his debtors. The book *Jack Brag* was published in three volumes. I was delighted to see that on his travels in the 1830s Jack spent a few months staying at a hotel at the Sea Houses, the section of modern-day Eastbourne close to the pier. It is clear that Hook himself stayed in Eastbourne.

Jack describes Eastbourne as humble but a very agreeable, clean, fresh and delightful place, but with nothing like gaiety going on – no grand balls, no crowded promenades and no house big enough to hold a decent party. The name of his hotel is not mentioned, but it had a garden facing the sea. To the east was Mrs Gilbert's tea

The Sea Houses, where Jack stayed.

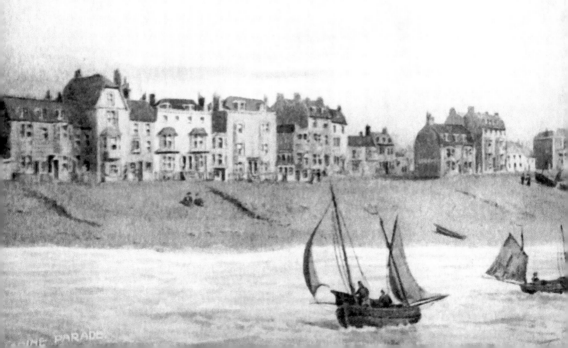

rooms and the lifeboat house. For dinner, Jack either ate locally caught fish or meat obtained from the butcher at Southbourne. Meals were washed down with half a pint of sherry and some small beer (a locally produced brew with low-alcohol content)

Jack regularly walked along the seafront to 'sniff the briny', but he says the two extreme points of civilisation at that time were the Watch House (occupied in all seasons by a gallant sea officer) and the Round House, which in the height of the season was occupied by a family of delightful tenants.

During his stay Jack frequented the library at the Sea Houses, but it is clear from his description that this was more like a gentleman's club where men went to smoke, read the papers and play billiards.

Jack visited Eastbourne before the big boon of sea-bathing and before the railway brought crowds in from London. Hook writes that anything is of interest at a seaside town. A glassblower who would be passed without attention in London is viewed as a thing of wonder and surprise in Eastbourne, and a fish that is longer or bigger than average attracts crowds of astonished onlookers.

Jack did not stay too long at Eastbourne. When the law nearly caught up with him, it was time to move on.

The Round House.

King's Club

When entrepreneur Ray King came to Eastbourne from London in 1961, the King's Country Club was a small caravan park just off the road between Eastbourne and Pevensey. He built the park up and by 1967 had opened a clubhouse. The *Stage* (a showbusiness magazine) reported that the new venue had a wonderful atmosphere with magnificent décor and good facilities for artists and bands. They suggested it could become one of the 'top niteries' in the country. Surprisingly, that's just what it became. Actors such as Tom Jones and Ella Fitzgerald graced the stage as well as many well-known bands such as the Supremes, the Drifters and the Four Tops, and comedians such as Ken Dodd and Bruce Forsyth. In July 1978 one of the first charity events was held to raise funds for the newly established Prince's Trust. Prince Charles attended the event and it was here that he famously climbed onto the stage and danced with the Three Degrees.

When the club was refurbished in 1985 over 1,000 people cheered on a new actor – Bobby Davro. The regular compare was Bob Summers, who continued to book top actors. The King's Club was one of a number of venues that made Eastbourne, to quote the *Stage*, 'the undisputed showbiz capital of the South Coast'.

Sadly, the King's Club is no more. The Kingsmere Estate now covers this once bustling place of entertainment.

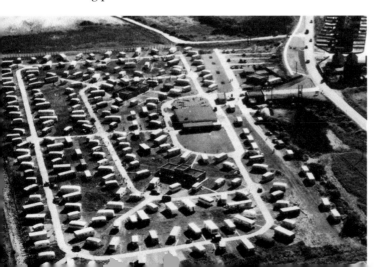

The King's Country Club.

L

Langney Priory

Langney Priory has a good claim to be the oldest building in Eastbourne. Said to have been built on the site of a Roman villa in the twelfth century, parts of it date to around the Norman Conquest. 'Langelle' (probably 'long island') was mentioned in the Domesday Book of 1086 when the land was held by William of Keynes, the priory was built just a few years later, probably as a monastic farm under the control of the great Cluniac Priory of St Pancras at Lewes. Records show that the monks managed eel fisheries, salt pans and had the 'right to free passage of sea-water for their mill'. This would have been a tide mill similar to the one that was later built between Seaford and Newhaven.

Known as Langney Farm, the buildings transferred to secular hands in the sixteenth century and did not gain the name 'priory' until 1919 when they sold for the princely sum of £1,300. The new owner was Mrs Sarah Williamson, previously the manageress of the York House Hotel on the seafront. By the 1930s the priory was the home of Mr and Mrs Charles Llewellyn, who also managed the dairy farm there, the surrounding fields being grazed by William Elphick, whose cattle won many prizes at agricultural shows. The priory was regularly opened to the public for church fairs.

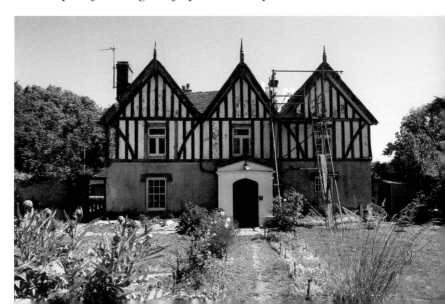

Langney Priory.

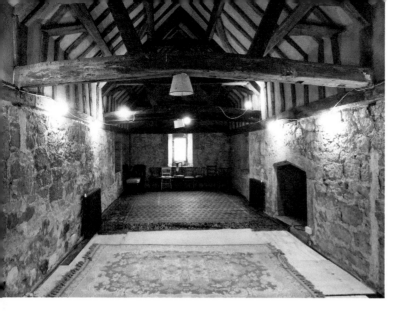

The priory's Great Hall.

In 1947 ownership of the priory was transferred to Mrs Marion Bettina Fenwick-Owen. Her son was Roderic (Roddy) Fenwick-Owen, who was an adventurer and author and came to Eastbourne to live with his family the following year. Within a few months the council published plans for the development of the area with housing. Mrs Fenwick-Owen worked with the Society of Ancient Buildings to ensure that her property was saved, and the priory received listed status in August 1949 (along with The Lamb Inn, Belle-Tout lighthouse, Compton Place and the Redoubt).

In 1951, 1,400 families in Eastbourne were on the waiting list for a home and the land around the priory was gradually purchased by Eastbourne Council. It was lost among modern housing but managed to survive, and today many local people would find it difficult to find.

Recently the buildings have had a new lease of life and it is hoped that the priory will be used as a venue for weddings and conferences. The priory is often open to the public and a visit is highly recommended. Of particular interest is the diminutive chapel, the great hall and a bees' nest that has probably been in-situ for centuries.

Leaf Hall

The Leaf Hall was built by William Laidler Leaf (1791–1874), who had made his fortune importing silk. When he visited Eastbourne for his holidays in the 1860s, he noticed that the unfashionable 'east-end' of Eastbourne had a large working-class population but few places of entertainment other than pubs. As a temperance man, he persuaded the Duke of Devonshire to donate a plot of land on which to build a church-like workman's hall. It was opened on 9 June 1864. It was renamed the Leaf Hall in January 1883. Many still remember the Leaf Hall as an antique market, but by 2009 it was abandoned. Luckily a small group of trustees raised the funds to restore the building and once again it is the centre for the local community, although you no longer need to be a teetotaller or a working man to visit.

The Leaf Hall.

Lifeboat

The story of Eastbourne's lifeboats and crews is one of extraordinary bravery and remarkable rescues. The first lifeboat was provided in 1822 by 'Mad Jack' Fuller (1757–1834), who also built the first local lighthouse at Belle Tout (see page 13). When he died, he left the lifeboat to the people of Eastbourne. The subsequent history of our lifeboats can be seen at the Lifeboat Museum near the Wish Tower.

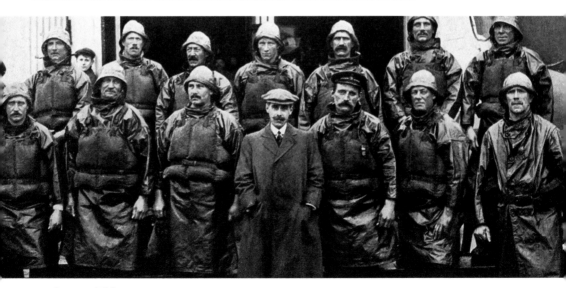

Eastbourne lifeboatmen, 1912.

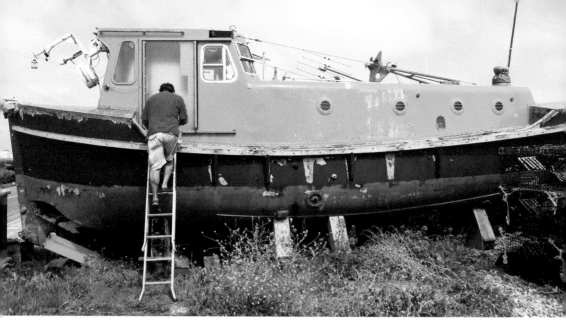

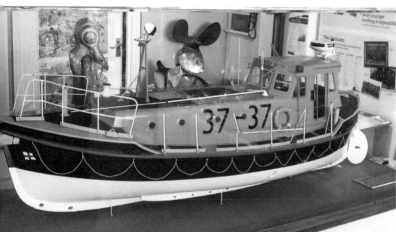

Above: The *Duke of Kent* awaiting restoration.

Left: The model in the Lifeboat Museum.

I recently had the opportunity to visit a decommissioned Eastbourne lifeboat – the *Duke of Kent*. It is currently awaiting restoration at the Allchorn Maritime yard. The Duke of Kent has been the president of the RNLI for over fifty years, and on 3 July 1979 he named the lifeboat that carries his name before a huge crowd at the Lifeboat Station. She was a Rother Class lifeboat (No. 37) and was built at a cost of £150,000, much of which was raised by the people of Eastbourne. She served until 1993, by which time she had been launched 353 times and was responsible for saving the lives of eighty-six people. A model of the lifeboat can be seen at the Lifeboat Museum.

The old lifeboat ended up in Tayside, but in 2017 she was purchased by Allchorn Marine and returned to the beach at Eastbourne, where she is awaiting restoration. Clambering onboard the lifeboat it is amazing to discover how small the wheelhouse is, but when you peer into the engine room you realise what power she packed. The *Duke of Kent* can today be seen at Fisherman's Green, just beyond the Redoubt. Occasionally the nearby Allchorn's boathouse can be visited to find out more.

M

St Mary's Hospital

Several of my ancestors were born in St Mary's Hospital in Church Street, a few yards away from where I now live. The building started as a cavalry barracks built in 1794 to house the mounted soldiers who would protect the coast in case of invasion.

After the Napoleonic threat had passed the barracks were converted into the Union Workhouse, which housed the poor from the area between Seaford, Westham and Alfriston. There was a strict regime of hard work for the inmates and married couples were separated. This led to a disturbance in 1835 when women refused to leave their husband's quarters. On my mother's side, my great-grandmother Mary Dutnall was an inmate of the workhouse and in 1900 gave birth to my grandfather there.

The workhouse was in use until the First World War when it was requisitioned by the army and became the Central Military Hospital. The workhouse inmates were moved out to the Hastings and Steyning workhouses. One of these inmates was my

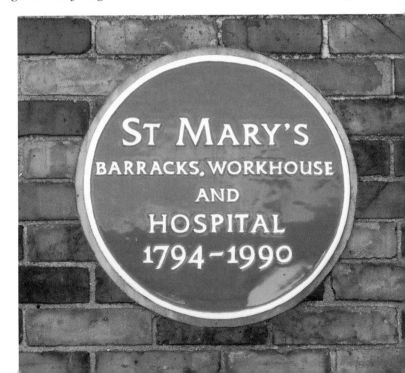

St Mary's Hospital
remembered.

great-great-grandfather John Roberts (on my father's side) who died at the Steyning Union Workhouse in 1918.

During the First World War thousands of wounded soldiers were treated at the hospital –some direct from the front and others from the Summerdown Camp (see page 76). The hospital war memorial listed 102 men and two women (nurses).

After the war the building did not revert to a workhouse but became a permanent hospital, and on 1 April 1930 was taken over by Eastbourne Council and renamed St Mary's Hospital. There was not only an operating theatre but maternity wards too, and by 1964 more babies were born at St Mary's than at the Eastbourne Maternity Hospital in Upperton Road.

The head nurse between 1924 and 1948 was Miss Mary Letheren and when the hospital closed and was demolished in 1990 a new road on the site was named after her.

Miss Eastbourne

Beauty contests were once a staple of holiday camps and seaside resorts. Traditionally, every village chose a young girl to be May Queen and by the early 1900s some places also annually selected a Carnival Queen.

The first Miss Eastbourne was crowned in 1934 when Yvonne Lower of No. 35 Greys Road was chosen by a ballot held during a ball at the Winter Garden. It seems odd today that the young girl's home address was given in the press. This was obviously a popular event as over 1,000 people turned up and there was a band. A collection was made for the Gresford Colliery Disaster Fund to support the families of the 266 miners who were killed. Yvonne was a popular choice and served as maid of honour to Eastbourne's Carnival Queen. The *Eastbourne Herald* reported that she had a striking personality and a happy disposition.

It seems that a new Miss Eastbourne was selected every autumn. A selection committee would whittle down the entries before the night of the competition and the winner was selected by the audience.

In 1937 Miss Eastbourne was crowned by Serge Vincent de Bolotoff, who was a member of the deposed Russian royal family. Known as Prince Wiasemsky, he was an early aviator and was married to Rosalie Selfridge, the daughter of the London store owner Harry Selfridge. The prince was staying at Eastbourne as a guest of the Duke of Devonshire.

Miss Eastbourne 1946 was Muriel Rowe, who was selected at a competition in Erith, Kent, to give publicity to south coast resorts after the war. Despite living in Kent she attended several regattas and events in the town. The following year it was decided that Miss Eastbourne would be selected every Easter. The winner would be over eighteen, live in Eastbourne and 'act as a hostess to welcome visiting celebrities and be present at local functions'. The girl would be selected for her 'charm, tact and

personality' and would be expected to have a 'pleasant speaking voice'. It took the judges (who included the mayor and several councillors) 3 hours to select nineteen-year-old Cynthia Lynch of Upperton Gardens as the winner.

Not everyone was happy and there were complaints that the contest was a 'stunt, more in keeping with Blackpool, Southend or Margate rather than the dignified town of Eastbourne'; however, the appointment seemed to have widespread public support.

The 1950s saw a boom in bathing beauty contests – probably helped by the introduction of television into many people's homes. The Miss World contest started in 1951. It was probably at this time when the contests became more commercial. The 1969 contest was held at the Curzon Cinema when the contestants had to parade on stage wearing swimwear during a showing of the James Bond film *You Only Live Twice*. Of the twenty-two finalists only three were from Eastbourne. In many people's eyes the competition was now out of step with modern values. Although 'pageants' are now held rather than beauty contests and there is still a Miss Eastbourne, the competition does not have the publicity or the public approval that it once had.

MISS EASTBOURNE '69

BATHING BEAUTY

FINALS

CURZON CINEMA EASTBOURNE

FRIDAY 21st MARCH 1969

131

Souvenir Programme 2/-

Miss Eastbourne 1969.

Motcombe Baths

To the left of Motcombe Farmhouse are the delightful Edwardian swimming baths. The baths were opened by the mayor at 8 p.m. on 5 January 1905 and the following day the building was open all day 'for inspection by the public'. The first caretaker was John Stoneham who was paid a joint salary with his wife of £2 a week to look after the new baths.

Originally known as Old Town Baths, the building contained slipper baths (twelve for men and three for women) as well as a large pool – 71 feet by 39 feet. Slipper baths are essentially what you have in your own home today, but in 1905 few of the houses in the area would have had the luxury of a bathroom. The building was made of red bricks from Keymer.

Eastbourne was one of the few towns in England where swimming lessons were provided as part of the school curriculum. Being a seaside town, it was thought important that the public should not only know how to swim but be proficient in life-saving too. The emphasis at this time, however, was on lessons for boys rather than girls. For 4*d* anyone could enjoy a good swim at Motcombe Baths unless they were a person of 'weak intellect' or suffered from 'fits or organic diseases'.

The water for the swimming baths is still drawn from the natural springs in the area.

Motcombe Baths.

N

Norway

Not many people realise that there is a part of Eastbourne called Norway! There used to be two routes from Eastbourne eastwards to the Cinque Port of Pevensey. The most direct route took you across the shingle of the Crumbles, but it was much quicker going the north way – or the nor'way. A pair of buildings on the eastern boundary of Eastbourne were called Norway Cottages and as other houses were built the area became known as Norway. Until 1877 the area was a part of the parish of Willingdon.

In the early 1880s Revd Edward Ebenezer Crake (1843–1915) was appointed the rector of the hamlet of Norway, which by then was within the parish of Christ Church. Crake was the founder and headmaster of Clifton House School and established the

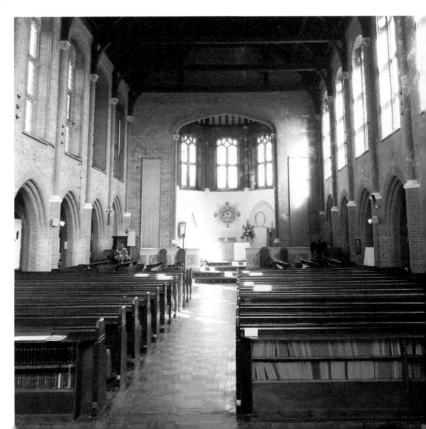

St Andrew's,
Norway.

Christmas Fund for members of the Eastbourne Borough Police and their families. He moved to the parish of Jevington in 1887 but retained his love of Eastbourne. He was a noted antiquarian and wrote several Sussex history books.

As Eastbourne expanded towards Langney a mission room was opened in Vine Square (just behind the present church) in October 1881 and this was used for services until 1885 when the 'Iron Tabernacle', previously used by the Baptist Church, was appropriated. This old, cold building served Norway for many years under Revd Hurney Whitchurch, but it was clear that a new church was needed. The foundation stone for a new church was laid by the mayor in October 1911 and it was consecrated on 25 July 1912. The lofty brick church is light and airy, which caused a problem in the First World War when it was found difficult to cover the long lancet windows to comply with the lighting orders.

The first vicar of St Andrew's, Norway, was Revd Harold Pain, who was a keen astronomer. When he was appointed in 1917, St Andrew's became a separate parish. In 1926, he transferred to All Saints in Lewes, but when he died in 1952 his ashes were laid to rest under the lady chapel of his Eastbourne church. A simple stone with a cross and the initials 'HP' marks the spot.

O

Ocklynge Cemetery

The Eastbourne Burial Board were responsible for buying 'Ocklyng Piece' in 1855 in order to establish a cemetery. A total of £2,000 was allocated to build a chapel and the cemetery lodge, which were designed by Benjamin Ferrey, who also designed Christ Church in the town. The cemetery was consecrated on 1 April 1857 and the first burial was held the following month on 25 May. He was Henry Ford, a seventy-three-year-old bricklayer from East Hoathly who had come to live in Eastbourne in order to build the cemetery chapel – so he is buried just a few feet away from his place of work. A few days later, on 1 June, the cemetery was officially declared open. In 1892 the cemetery was extended north to Eldon Road.

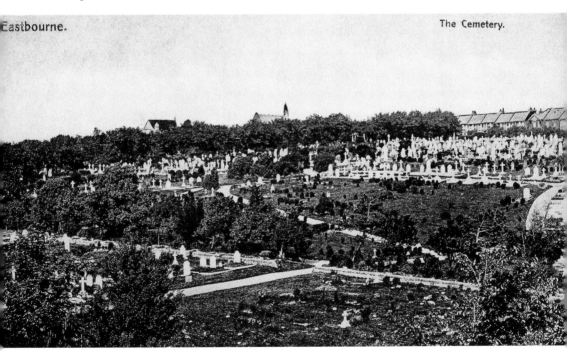

Eastbourne. The Cemetery.

Ocklynge Cemetery.

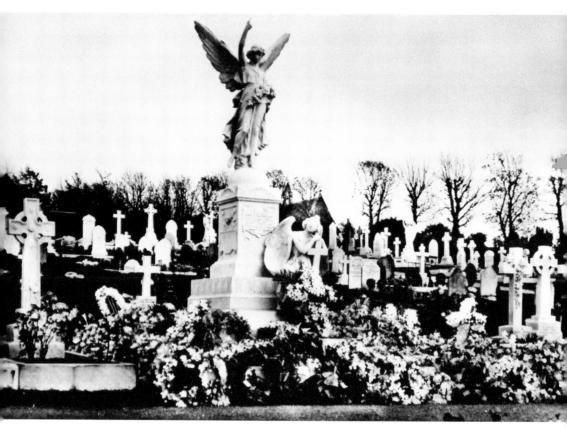

The Rube Memorial.

The cemetery contains many war graves. One of them – for Lieutenant Colonel Oswald Fitzgerald – was designed by Charles Rennie Macintosh. The cemetery contains many members of my own family and when I visit I always stop and pay my respects at the grave of Police Inspector Walls, a local man who was shot dead in 1912, and Henry Jones, a recipient of the Victoria Cross. The cemetery even has the graves of two prime ministers' wives, but the grandest memorial is for Rube family. Charles Rube was a diamond dealer and his memorial angel is the largest in the cemetery.

P

Paradise

Paradise Drive is a lovely rural road linking Old Town with Meads and cuts across the golf course. It is named after the Paradise Plantation which in turn was named after a place name in Northamptonshire as the land here was once owned by the Earl of Northampton. Close to the drive is a small flint-built belvedere, a small folly to add some interest to the view from Bourne Place (later Compton Place). It was probably built in 1740 but the first known picture of it dates from 1783.

Paradise Drive with the folly.

St Mary's Parish Church.

Parish Church

I am lucky to live next to the parish church of St Mary's in Old Town. The robust greensand blocks, which were probably quarried from close to the pier, seem to glow in the evening sunlight and the bells are the same as those that were heard by my ancestors. The church dates from Norman times and may have originally been dedicated to St Michael. The chancel is the oldest part of the building, and the church guide will give you its full history. A recent detailed examination by Heritage Eastbourne has revealed hundreds of pieces of graffiti dating from the medieval period. These include daisy-wheel patterns, ships and hundreds of scratched fish. Most are visible only with specialised lighting. The purpose of this graffiti has been lost over time, but this research may help in understanding the lives of our Eastbourne ancestors.

Parsonage

The Parsonage adjacent to St Mary's Parish Church was built for Hugh Rolfe in the early sixteenth century and is a good example of Tudor architecture. In Victorian times the building was converted into three dwellings, but it became dilapidated and was given to the church by the Duke of Devonshire in 1900. It was restored and is now church offices and a large hall, which provides a meeting place for parishioners. The listed building is also home to the church caretaker. The old well that can be seen in the garden was capped in 1896 when the water was deemed unfit for human consumption.

The Old
Parsonage.

Pavilion

The Pavilion was once a part of the Redoubt Music Gardens, which could seat 2,000 people. The bandstand was moved here from Marine Parade in 1922. During the 1930s 'Health & Fitness' demonstrations were held with performances by gymnasts such as the 'Daily Mirror Eight' who performed in July 1935 wearing 'sapphire blue oil-skin bathing costumes'. One performance attracted a crowd of nearly 12,000 people.

Today the Pavilion has a tearoom and an exhibition space used by Heritage Eastbourne for temporary historic displays – free and always worth visiting. The gardens of the Pavilion have two Royal Sussex Regiment war memorials, one to commemorate Nelson Carter VC and another to members of the regiment who fought and died in the Burma Campaign during the Second World War.

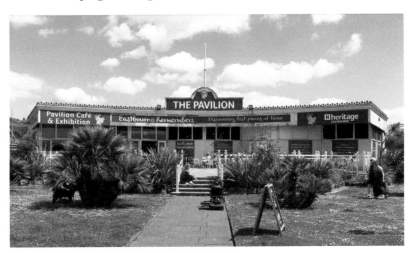

The Pavilion.

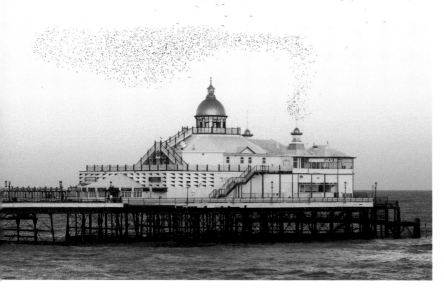

The pier at twilight.

Pier

'Eastbourne wouldn't be Eastbourne without its pier' said the chief engineer Paul Dixon when I visited it recently. I could not agree with him more. Paul knows every part of the 300-metre-long structure, which must be one of the finest Victorian piers in the country. It was designed by the famous Eugenius Birch (1818–84) and fully opened in 1872.

Over the years the pier has had concert halls, nightclubs, theatres, shooting galleries, tearooms and amusement arcades. As a teenager I often attended the 'Dixieland Showbar', a disco at the end of the pier.

On New Year's Day 1877 much of the pier was destroyed in a storm and it suffered two catastrophic fires in 1970 and 2014. It was even damaged by a floating mine and enemy machine gunfire during the Second World War. Today the pier is really looking great. Its new owner, Sheikh Abid Gulzar, has invested in new paintwork and ensured that several Union Flags always fly. Although the gold-painted domes are not everyone's cup of tea, I think that Eugenius and the pier's Victorian visitors would have loved the new colour scheme.

Pleasure Boats

Local maritime historian Ted Hide has published his research on the fishermen and pleasure boatmen of Eastbourne. Although pleasure boats were fun, they played an important part of the industry and wealth of the town. Just after the war two new boats were commissioned for Sayers, a company who ran boats from the beach to the west of the pier. They were the *Southern Queen* and the *Eastbourne Queen*. Another larger boat was the *William Allchorn*, made in Newhaven for Allchorn Brothers, who used the

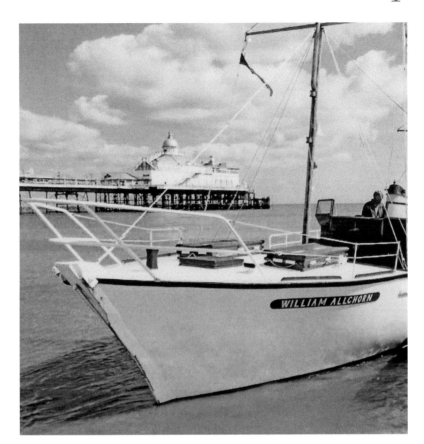

Right: The
William
Allchorn.

Below: The
Southern
Queen during
restoration.

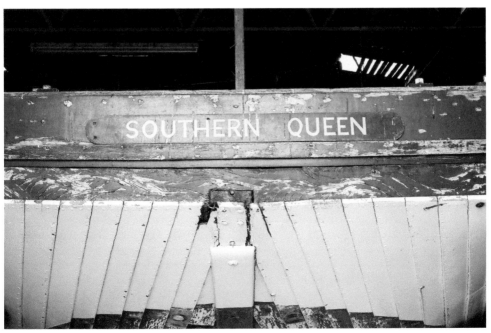

beach next to Sayers. The boats are seen on many postcard views of Eastbourne, either on the beach or chugging towards Beachy Head for a trip around the lighthouse.

With an increase in cheap air travel and foreign holidays, visitor numbers dropped in the 1960s. Ernest Sayers retired, and the *Southern Queen* was sold to Allchorns.

Sadly, the *Eastbourne Queen* ended its life as a houseboat on the Norfolk Broads, and by the 1990s the two others were taken out of commission. The hull of the *William Allchorn* can be seen at Fishermans Green outside the boathouse for Allchorn Maritime. The boathouse includes a small museum and the *Southern Queen*, which is in the process of restoration. A visit is highly recommended. It would be fantastic to see a pleasure boat back in service at Eastbourne once again.

Poetry

My great-grandfather Ebenezer Roberts was born in High Street, Eastbourne, in August 1867. His father had a bath-chair pitch on the seafront and the young Ebenezer was the owner of a goat chaise. Although he later became a greengrocer, he spent much of his life working as a painter and decorator. After his marriage to my great-grandmother, Bessie, they moved to Taddington Road. He was the chairman of the Eastbourne Old Age Pensioners Committee and Grand Master of the local branch of the Manchester Union of Oddfellows. He was a royalist and the head of the local bonfire society. His main passion, however, was poetry. Ebenezer wrote religious verse and every family event was celebrated by a poem. He wrote about walks on the

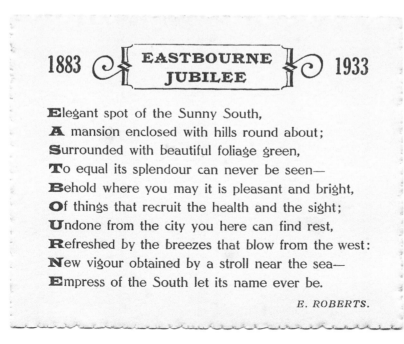

1883 ⌖ EASTBOURNE JUBILEE ⌖ 1933

Elegant spot of the Sunny South,
A mansion enclosed with hills round about;
Surrounded with beautiful foliage green,
To equal its splendour can never be seen—
Behold where you may it is pleasant and bright,
Of things that recruit the health and the sight;
Undone from the city you here can find rest,
Refreshed by the breezes that blow from the west:
New vigour obtained by a stroll near the sea—
Empress of the South let its name ever be.

E. ROBERTS.

Eastbourne Jubilee acrostic.

Some of my great-grandfather's poems.

South Downs and about events he attended such as the unveiling of the Protestant martyr's memorial on the Downs above Lewes.

Many of his poems were acrostics, where the first letters of each line of poetry spell out a word or name. My favourite was written in 1933 to commemorate the fiftieth anniversary of the borough of Eastbourne.

As a royalist Ebenezer wrote about royal births, deaths, jubilees and marriages, and he was so proud of his work that he had his poems printed on card. These were sent to London and he must have been thrilled to receive the acknowledgements sent back to him in small unstamped envelopes embossed 'Buckingham Palace'. The earliest I have is dated 1897, sent to Queen Victoria on the occasion of her Diamond Jubilee. He must have been pleased when his daughter Bessie Victoria also took up poetry.

The last poem my great-grandfather wrote was for the forthcoming marriage of our present queen and Lieutenant Philip Mountbatten on 20 November 1947. It was sent to Buckingham Palace and Ebenezer received a reply from the lady-in-waiting to Princess Elizabeth thanking him for his 'charming poem'. The letter is dated 3 November 1947, but Ebenezer died just a few days later. Many of his poems were later published by my grandmother.

I still have a portfolio of Ebenezer's poetry and the acknowledgements from Buckingham Palace. He was clearly a passionate and deeply religious man. His obituary, published in the *Eastbourne Gazette*, says that he was 'always willing to give advice to others'. His poetry is not brilliant, but his love of Eastbourne is clear.

Queens Hotel

The splendid Queens Hotel was built by Henry Currey (1820–1900), the architect of the Duke of Devonshire. There were gushing reviews of the hotel when it opened to the public on 1 June 1880. There were sixty bedrooms on five floors, but only two bathrooms and, amazingly, no toilets – they were provided in a separate wing.

The hotel furniture was provided by Maples of Tottenham Court Road, London, which was made with walnut on the first and second floors, pine on the third floor and oak on the top two floors. All rooms were provided with tapestry curtains

The Queens Hotel.

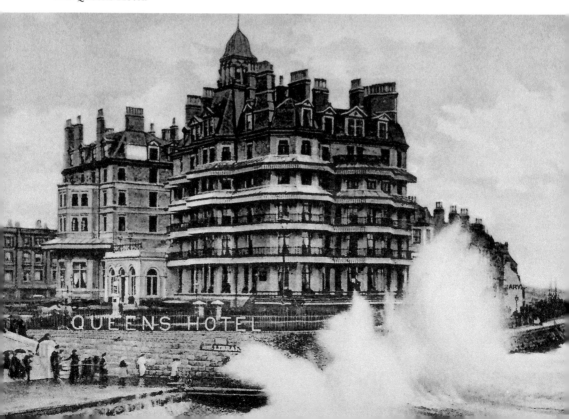

and carpets from Brussels. There was a basement restaurant, which, for some reason, had separate dining rooms depending on whether you were eating hot or cold food, a large drawing room with a piano, a library, a ladies only room and a smoking room. A hydraulic lift could take you to the top of the hotel where there was a viewing tower.

The Queens Hotel formed a barrier between the posh hotels of Grand Parade and the cheaper establishments to the east. Indeed, until 1898 there was no continuous road here, just steps at Splash Point down onto Marine Parade.

Quiz

What has a quiz on American TV got to do with Eastbourne? Remarkably, the old Manor House in Old Town was once considered as a prize in a programme called 'Bid and Buy' sponsored by the cosmetics company Revlon.

The house dates from the sixteenth century and was once home to the lord of the manor; however, when Charles Gilbert moved into a new home in 1797 the old house lost its status. In 1958 the owner of the old Manor House, William Hipwell, tried to sell it to the CBS network in the USA to use as a quiz prize. The company had previously courted controversy when they tried to buy a Scottish island.

The previous year Mr Hipwell had tried to sell the Manor House to the council in order to convert it into a museum, but there was a dispute about the cost so Mr Hipwell sold off the contents and many of the fittings and moved out. He also claimed the title lord of the manor, which the council disputed. Maybe that is the reason why one of Eastbourne's oldest buildings is not in American hands today.

The Old Manor House prize.

Railway

The Brighton, Lewes and Hastings Railway was formed in 1844. The proposal was to run a double line from Brighton to Lewes and a single line from Lewes to Hastings. The station for Eastbourne was to be at Polegate, over 4 miles away. It took another few years before a branch line was made into Eastbourne and the first train arrived

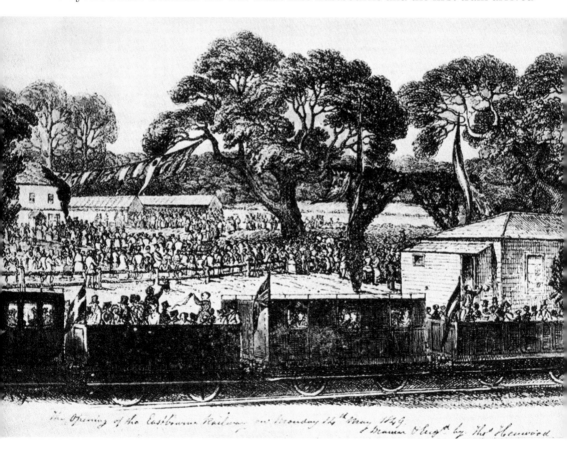

The first train arrives at Eastbourne, 1849.

at the new railway station on 14 May 1849. The event was marked by speeches, sports and, in the evening, fireworks. A total of 850 members of the parish poor were treated to a loaf of bread, cheese and a pint of beer each in the field next to the station, which shows how rural Eastbourne was at that time.

The *Sussex Advertiser* described the line between Polegate and Eastbourne as being 'dead flat and crossing no road or rivers'. It goes on to report that the station was ideally situated at a central point between Eastbourne, Southbourne and the Sea Houses. The station was very primitive – in fact little more than a wooden hut, 20 ft by 12 ft. In 1866, a second station was built. This was superseded in 1872 when the old station became a refreshment room. The present station dates from 1886, so in the space of just thirty-seven years Eastbourne had four different railway stations.

Royal Sovereign

There are several sandbanks or shoals off Eastbourne, including Elphick's Tree, the Horse of Willingdon, Kinsmans Nab and the Spot Shoal. Some even become small islands during very low tides. Collectively they are known as the Royal Sovereign Shoal, named after HMS *Royal Sovereign*, which floundered here in the eighteenth century.

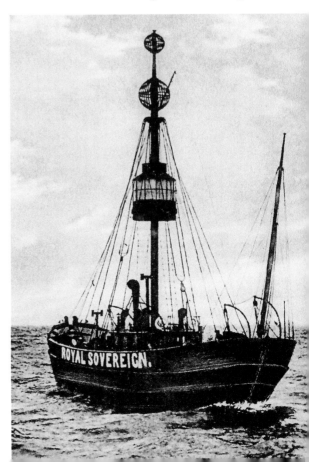

The *Royal Sovereign* lightship.

The shoal, around 7 miles off Eastbourne, had been a major obstacle for local shipping for many years, so in April 1875 a lightship was moored nearby. The vessel showed a revolving white light to warn shipping. Later a coal-powered siren was added to warn shipping during the many sea frets. Essential provisions for the lightshipmen were taken out by a Trinity boatman, Mr Jesse Huggett of Beach Road, on his steam yacht, *Prince Consort*. Books and newspapers were supplied to the ship by Mr Giddins of Latimer Road. He was the local representative for the Missionary to Seamen Society. Every Christmas several men would brave the choppy seas to deliver parcels to the *Royal Sovereign*. These included Christmas puddings, fresh meat, fruit and vegetables. In 1902, the gifts (including a gramophone and some records) were conveyed out to the lightship by the mayor himself.

The lightship provided salvation to thousands of vessels. In December 1891 it needed assistance itself when it broke from its moorings during a storm. It sent up signals that were seen by the piermaster, who advised both the local coastguard and Trinity House. A P&O steamer bound for India stopped to give assistance and the lightship was remoored the following day.

Before radio, the lightship was out of contact with the rest of the world. When the Siege of Mafeking was lifted, a launch was sent out to give the news to the crew. In 1907 the ship was fitted with underwater equipment for warning submarines of the dangerous shoals. Apparently, the underwater bell could be heard by submarines at a distance of some 12 miles. It was also equipped with a louder siren known to locals as 'Moaning Mary' and described as having the noise of a cow who had lost her calf.

The lightship was removed during the war and in 1946 replaced by a new lightship built on the River Dart in Devon and fitted with radio. The ship was still regularly visited by Jesse Huggett until he was well into his eighties.

In 1971 the ship was replaced by a light tower also known as the Royal Sovereign. It was constructed near Newhaven. It was originally manned but in 1994 became fully automatic. In June 2019, Trinity House announced that the light tower would be decommissioned and removed by 2020.

S

Saffrons

The Saffrons is a sports ground near the Town Hall and comprises facilities for cricket, football, hockey and croquet. It is the home ground for Eastbourne Town FC and in the past Manchester City and the England squad have used it as a training ground. The cricket pitch has been in use since the 1880s and is often used for county matches.

The origin of its name is obscure. The *Eastbourne Gazette* of October 1877 refers to Saffron's Field belonging to (of course) the Duke of Devonshire. The apostrophe may indicate that it was named after someone, rather than being a field where saffron was grown.

In 1911, Alderman John Chisholm Towner paid the duke £2,000 for a ninety-nine-year lease on the ground as a coronation gift to the people of Eastbourne.

The Saffrons.

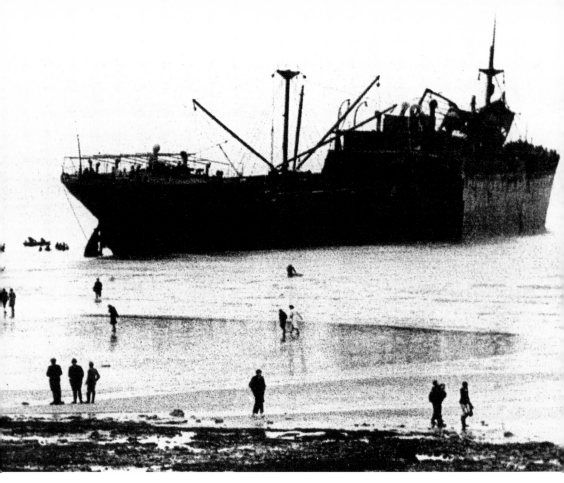

The *Barnhill.*

Shipwrecks

I remember one blustery day in October 1968 when my dad took me down to the seafront at Meads to see the wreck of the Norwegian oil tanker *Sitakund*. When she was off Beachy Head an explosion set the ship ablaze and three of the crew were killed. She beached at Holywell and the lifeboat and Eastbourne Fire Brigade helped to tackle the blaze. Eastbourne residents were told to keep their windows closed and there were fears of an oil slick.

The sinking of the SS *Oceana* on 16 March 1912 is particularly notable. She collided with a sailing ship 7 miles off Eastbourne. The Eastbourne lifeboat crew braved the stormy seas to rescue the forty passengers on-board. The Royal Navy later blew up the wreck but failed to recover the gold and silver ingots, which were lost in the wreck.

Mike Keane of Sussex Shipwrecks (a local diving company) tells me that the *Oceana* is one of over 340 shipwrecks in the Eastbourne area. These are, of course, underwater, but the boilers of the SS *Barnhill* can still be seen off Langney at low tide. She was attacked by an enemy aircraft on 20 March 1940 and towed to the shore. Local people (including members of my own family) salvaged some of the hundreds of cans

of food that were washed up from the wreck. The trouble was that they had no labels, so you did not know what was for tea until the tins were opened! There is now an interpretation board near the Sovereign Harbour giving more information.

Skittles

Spencer Cavendish (1833–1908), 8th Duke of Devonshire, was rather revered in Eastbourne because of his financial support to improve the town. Outside of Sussex he was generally known as the 'Marquess of Hartington'.

Although a Liberal politician, he opposed his party's opposition to home rule for Ireland and afterwards became quite conservative. During a long career he served as the Secretary of State for War, the Postmaster General and the Secretary of State for India. He declined the office of prime minster on three occasions.

Despite his political pedigree, Spencer had an interesting private life. His nickname was 'Harty Tarty' and he had long affairs with two women: the celebrity courtesan Catherine Walters who was known as 'Skittles', and Louisa von Alten, a German who was married to the Duke of Manchester. (As she was married to one duke and was having an affair with another she was known as the 'Double Duchess'.)

A 'courtesan' is essentially a posh prostitute, and the duke provided Skittles with a house in Mayfair and an annual allowance. She was a skilled horsewoman and would regularly be seen parading along Rotten Row. Sir Edwin Landseer's picture, *The Shrew Tamed*, is supposed to represent Catherine.

In 1876 the duke paid an official tour to Coventry. The Prince of Wales (later Edward VII), knowing this, primed his equerry to contact Coventry Council to ensure that the visit included a trip to the local bowling alley. When the party arrived at the bowling alley the mayor was surprised that he did not show much interest, so unwittingly said to the duke 'I have been asked to include the alley in your tour as I understand that your Lordship is very fond of Skittles!'

The duke favoured the German duchess, but he had to wait until she was sixty and her husband died before they could marry. She died in 1911 and was buried near Chatsworth House.

Skittles, who had been born near Liverpool Docks, died a rich lady in Mayfair in 1920. As she had returned 300 love letters to a grateful Edward VII, who had also been her lover, he ensured she lived comfortably. She is buried in Sussex at the Friary Church of St Francis and St Anthony in the centre of Crawley.

Harty-Tarty died in 1908 and his lonely statue now adorns the Western Lawns, opposite the Grand Hotel. The Hart pub and Hartington Place are named after him, but wouldn't it be fun if an Eastbourne twitten was named 'Skittles Alley' after his lover?

Southbourne today.

Southbourne

Southbourne was the area that grew around the present-day South Street. It was originally a separate village, known by local people as 'South'. The New Inn was built at the north end of the village in around 1700 and was a stopping place for stagecoaches. It was also a place of entertainment and regular auctions were held there.

South Cliff Tower

Eastbourne has always been a genteel resort and the dukes of Devonshire and the Corporation ensured that it stayed that way. Maybe it is the only seaside town in the world that, even today, has no shops, restaurants or amusements arcades on its seafront.

The South Cliff Tower.

You can imagine therefore the consternation caused when it was announced in 1965 that a skyscraper was to be built among the Victorian and Edwardian villas of Meads. When the council granted planning permission there was a storm of protest, especially when it was discovered that the land was owned by a former councillor. A protest group was established to channel public concerns about the building, and this transformed into a preservation society now known as the Eastbourne Society.

The building is in the form of a double connected tower, each nineteen storeys high. It affords wonderful views, but I have heard some say that the best thing about the view from the South Cliff Tower is that you can't see the South Cliff Tower! The building incongruously appears in the opening sequences of the 1969 war film *Battle of Britain*.

Street Names

A guide to the street names of Eastbourne was published by the Eastbourne History Society in 1973 and a more comprehensive edition is currently being compiled by Eastbourne historians Alan Smith and Michael Ockenden. Many of the roads built on land owned by the dukes of Devonshire were named after places on their estates in other parts of the country. For instance, Ashford, Churchdale, Darley, Staveley and Tideswell are all places in Derbyshire; Bolton and Grassington are in Yorkshire; Grange, Milnthorpe and Silverdale are in Lancashire and Lismore and Moy are in Ireland. Astaire Avenue is named after the dancer Fred Astaire's sister Adele, who married into the Duke of Devonshire's family.

Many streets are named after houses that once stood there; for instance, Susans Road is named after Susans Farm.

Ecmod Road was the site of a bus depot and stands for Eastbourne Corporation Motor Omnibus Department.

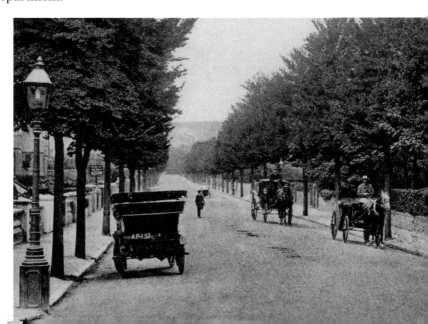

Silverdale Road.

Summerdown Camp

The Summerdown Camp was established in 1914 for military personnel who had been wounded in action or otherwise injured. The camp was originally started by the Royal Army Medical Corps at Whitbread Hollow between Meads and Beachy Head, but later moved to the north of the Workhouse (later St Mary's Hospital) on the East Dean Road.

The first convalescents arrived in April 1915 and were issued with a blue uniform, which became a badge of honour and the men were referred to as 'Blue Boys'.

The Under Secretary of State for War, Sir James McPherson, was asked in the House of Commons about the facilities for 'wounded and legless' soldiers at Summerdown Camp. He said,

> The camp is a little over 1½ miles from the sea, and the distance to shops in the Old Town is about 400 yards, and to the best shopping centre in Eastbourne about one mile. There are several routes from the camp to the sea, and on some of these there are seats; in Gildredge Park there are some 100 seats, the nearest being about 500 yards from the camp. There is also a good bus service from the centre of the town to within about 100 yards of the camp. There is only one legless soldier in the camp, and it is hoped to make arrangements to transfer him to a hospital nearer his home.

Summerdown Camp.

No. 8.
Saturday, Nov. 6th, 1915

The Summerdown Camp Journal

Y.M.C.A.

PRICE 1d.

— THE — 'BOY BLUE'

Souvenir Dolls and Mascots

State Protected, Registered and Copyright Designs.

PURCHASERS of these Big Boy Blue Souvenir Dolls and Mascots, in addition to having an interesting memento of the Great War, will be materially assisting the recreation and entertainment of the wounded. One half of the nett profits of the B(oy) B(lue) Syndicate, Ltd. go to provide additional monies for the entertainment and succour of the N.C.O.'s and Men of H.M. Army, wounded and convalescent in certain Military Convalescent Hospitals.

Orders will be executed post free of charge in the United Kingdom ; if to be sent abroad, postage or carriage must be included.

Minimum Price List of Boy Blue Souvenirs.

All State Protected, Registered and Copyright Designs.

SUITABLE FOR CHRISTMAS PRESENTS.

The Big Sergeant, The Corporal, The Little Corporal (14-in. high, with distinctive stripes) 6/6
Thomas (8-in. high) 1/6 and 2/-
Spoons, 4/6 and 5/- (Sets of Six, 25/- and 28/6) Cases (lined with velvet) 4/6
Convertible Brooch Pendants (enamelled in colour) ... 2/- & 3/6
Hat Pins (3 kinds) 1/6 each. Safety Pins, 1/6 Scarf or Tie Pins, 1/3
Statuettes, Charms or Mascots, of various prices and sizes to order.
Artistic Boy Blue Picture Postcards, in colour, with verses, 1d. each (copyright)
Artistic Boy Blue Calendars for 1916, are in course of printing.

Obtainable by application with WRITTEN ORDER and remittance (not stamps).

Or at the DEPOT of

The Eastbourne B(oy) B(lue) Syndicate Ltd.,

35 CHURCH ST., EASTBOURNE (A FEW DOORS FROM ST. MARY'S CHURCH)

This Company supplies all the Camps and Hospitals and the districts in which they are situated.

Above left: A Blue Boy.

Above right: *Summerdown Camp Journal.*

On Sunday afternoons, volunteers used Eastbourne buses to take injured soldiers for rides round the district. In 1916 buses were also used to take members of the Summerdown Camp band to the bandstand to give concerts. After around six months of this, the council complained that the soldiers were being paid for playing and so should not expect free transport to their venue. It was also argued that playing music for money on the Sabbath was a contravention of the Sunday trading laws.

My great-uncle Bertie Bennett printed the *Camp Journal*, which in May 1916 recorded the visit of George V and Queen Mary. The camp closed in February 1920, by which time around 150,000 men had passed through. Old Camp Road commemorates its main entrance.

Taxi!

Margaret Scott was born in France in 1882, but in her twenties moved to Eastbourne to run a boarding house in Meads (a role deemed suitable for a woman).

On 31 January 1916, she obtained a licence to drive motor cars and purchased a car. She enjoyed driving long distances and claimed that motoring was good for her. She said, 'I was never very strong but motoring has improved my health. I used to suffer from colds and other ailments but since I have taken to motoring this has ceased. If I leave off motoring my health declines but now I am very fit.' She said she could cycle 80 miles in a day or walk over 20 miles. She had been hired on several occasions to drive passengers, but this had been a private arrangement. Margaret wanted to be a taxi driver.

Women had been allowed to drive taxis in Vienna as early as 1912 and were quaintly called 'chauffeuses'. A report said that only 'middle-aged' women should be appointed but refreshingly said that 'if there were more women drivers many accidents would be prevented'. The lack of able-bodied men during the war saw many women drivers but few were permitted to drive taxis.

There had been female taxi drivers in Scotland as early as 1915. The following year a request had been made in Yorkshire for women to be taxi drivers, but this was refused on the basis that it would be dangerous to the women themselves. The chairman of the Watch Committee in Leeds said, 'What if it was a dark night and a woman tax-driver was hired by a man worse for liquor? He could refuse to pay his fare or even worse and we must guard against such things!' Other councils agreed. In Burnley it was said that 'the public don't want women drivers', and in Walsall it was said that taxi driving was too rough for women. However, there were women taxi drivers in Manchester and Newcastle by September 1916.

In July 1916, it was suggested to one Sussex taxi company that they might employ women, but Mr Bodle, who ran twenty taxi cabs in Eastbourne, said 'Ladies object to the hours they have to put in. The hours of work extend beyond midnight and ladies will not face it. Taxi driving is not suitable for women!'

Margaret disagreed and in the early weeks of 1917 she applied to the Eastbourne Watch Committee for a licence to run a taxi. The press was sceptical and said that

Margaret Scott in her taxi.

although her driving skills were not in question, she would be unable to assist her passengers with heavy luggage. She appeared before the Watch Committee and reported that she had driven nearly 9,000 miles without incident. The committee decided that if she wanted the licence she would have to prove her driving proficiency to the satisfaction of Mr Percy Ellison, the manager of the Eastbourne Motor-Bus Department. This was not a requirement for male drivers.

I am sure Margaret was nervous of having to have a 'driving test' with Mr Ellison, as his views on women drivers were widely known. The previous year, when asked why women should not take the jobs of male bus drivers so they could be released for war service, he retorted 'Sir, if this course is taken I would not like to be responsible for the safety of the public!'

Percy, however, was very impressed with Margaret's driving skills and his report to the Watch Committee was so favourable that she was immediately granted a taxi-cab licence.

She plied for hire in a bright yellow car, which became known as the 'Yellow-Bird'. The *Eastbourne Gazette* sang her praises and reported in March 1917 that she had taken fares as far away as London and Southampton (before dinner!), and had recently driven to Seaford before breakfast and returned to Eastbourne to convey passengers to Margate.

Margaret was one of the first female taxi drivers in the south of England. London did not get its first female taxi driver until November 1917. By the end of the war it was not unusual to see woman taxi drivers. Today we don't give a second look to a woman driving a taxi, but 100 years ago it was so unusual that the first Sussex taxi driver made the national papers.

Tennis

In August 1875 a report in the *Eastbourne Gazette* mentioned that visitors could hire a horse, play billiards, skate on a rink or enjoy lawn tennis (without being mobbed by vulgar people!)

Tennis has been played at Devonshire Park since 1879 when courts were laid out near the cricket pitch. The South of England Tennis Championships were held there from 1881, and since 1974 the Women's Tennis Association have held an international competition in early June as a prelude to the Wimbledon Championships.

SOUTH OF ENGLAND LAWN TENNIS TOURNAMENT AT DEVONSHIRE PARK, EASTBOURNE
LADIES' AND GENTLEMEN'S DOUBLES

Mixed double, 1888.

Towner

In 1920 Eastbourne cabinetmaker and former Alderman John Towner, who lived in the Grotto in Burlington Place, left twenty-two paintings to the people of Eastbourne with a bequest to establish an art gallery. The Towner Art Gallery was opened in the Manor House (the former Vicarage) in Old Town in 1922. The displays were originally Sussex related and there was some consternation when the gallery diversified. After the gallery purchased some prints by Pieter Brueghel in 1938 the local paper carried a letter saying, 'Why should the ratepayers be asked to foot the bill for those who want to study Flemish low-life?'

In the 1980s some rooms in the gallery were set aside for a local history museum and I was pleased to help in putting the displays together. Many thought that the gallery was too small and its location not convenient for visitors so a new purpose-built gallery was proposed. The gallery at the Manor House closed in 2006 and the bright new gallery opened near the Congress Theatre in April 2009. Sadly the museum was never rehoused.

Today the Towner is one of the foremost galleries in the country and has some good exhibitions – I particularly like the annual art displays created by local schools. Also, there is a cracking café on the top floor with fine views over the tennis courts.

Towner Gallery.

Urinals

Despite our idea of Victorians being genteel and prudish, they would have got used to seeing people going to the toilet in public. If you stayed at a hotel or inn you would have to use a chamber pot and, as your room may well have been occupied by several people, privacy was not an option. The Lamb Inn had a more sophisticated solution with a two-storey garderobe (mistakenly identified in the past as a smugglers tunnel). Even if you stayed at a 'posh' hotel there were no en-suite facilities.

I understand from archaeologist Lawrence Stevens that when the old Star Brewery site (now Waitrose) was excavated it was clear that structures across the Bourne Stream were early toilets, convenient to the householders but maybe not so pleasant for people who lived downstream.

It appears that the first suggestion of a public lavatory in Eastbourne was in 1870. It was reported that during the annual regatta, as there were no public toilets, over 1,000 people had made use of a stable near the pier. (It would be interesting to know if the owner charged and if there were separate facilities for men and women!) The Eastbourne Ratepayers Association therefore held a meeting December 1870 and called on the Local Board (the council) to provide urinals on Grand Parade. The council agreed and asked the association to suggest suitable locations. Although it was thought that the best place would be under the pier, the pier company objected saying that many people sought shelter there during inclement weather and the urinal may become a nuisance. It was agreed that the most suitable place was near the pier toll house. The council agreed and the following month it was decided to build a 'place of convenience' at the foot of the steps to the west of the pier.

A year later there were still problems and it was necessary for the ratepayers to again press the Corporation for better public toilet facilities, 'there being violations of public decency arising for the want in proper conveniences'.

A public toilet must have been erected at the Wish Tower in 1873 as in January 1874 the council paid £30 for a wall and a rockery around the urinal to hide it, but later in the year the War Department complained that the urinals had been built on their land without their consent. In 1882 there was a complaint that the Wish Tower urinals were not properly signposted as 'many ladies often mistake the entrance to the urinal for the

The Hampden Park urinal.

entrance to the Wish Tower'. This is interesting as it is clear that the early urinals were not signposted. It wasn't until 1890 that the council decided to have a notice outside them with the word 'Gentleman'. Surprisingly, at least one councillor objected.

In the 1870s and 1880s a number of public urinals were built across the town, although it is clear from reports that these were not fitted with a supply of running water. Probably because of this, there were several complaints about urinals becoming a 'public nuisance' to people who lived nearby and in 1882 the council agreed that none would be built without public consultation. At the same meeting it was proposed that urinals be installed 'in the trees in Trinity Place', at the back of the Sussex Hotel and by the Rose and Crown pub in Langney Road. One councillor said there was 'nothing wrong with a nice iron urinal'.

In 1883, it was stated that the influential Duke of Devonshire was against the erection of urinals and when 'these indecent places were built they very much depreciated the value of nearby property'.

Not everyone used the public conveniences and in 1894 there was a suggestion that public toilets on the seafront be provided free of charge. The correspondent to the

local paper said that the only public toilet was 'miserable' and a penny was charged. He said that if the fee was waived local fishermen may even use it. It was in this year when public toilets near the bandstand were proposed.

A public lavatory was built at the junction of Cornfield Road and Hyde Gardens in 1900. At a council meeting Councillor Francis angrily objected, but Councillor Wenham stated that there was no better location for a convenience in the whole town. This is also the first council meeting I have seen where there is a mention of 'provision of lavatory accommodation for ladies'. As a result there was a proposal to build a ladies toilet at Trinity Trees, but, following complaints from councillors (who were all male), the scheme was rejected.

In the following years and as the town expanded, a number of euphemistically titled 'public conveniences' were built around the town. Many were painted to blend in with their surroundings, but maybe the most unusual one was installed among the trees at Hampden Park. This was a French style cast-iron pissoir. It was built at the MacFarlane's Saracen Foundry in Glasgow and was originally painted green to blend in with the scenery. Amazingly, this four-stall urinal is still in-situ, but has suffered from neglect and vandalism. The art deco design is still clear and for a gents' toilet it really is a thing of beauty. I do hope that one day it can be restored and returned to its former glory.

V

Visitors

Jack Brag (see page 44) was one of the first recorded visitors to Eastbourne, but there have been many since. Although the town's economy relies on its visitors, they have not always been welcome. In 1887, they were described as 'invaders'. One day in September that same year 900 members of the London Licenced Victuallers Society arrived by train. One man wrote to the paper afterwards objecting to 'this class of visitor' being encouraged complaining that there were now less 'upper and upper middle class' visitors than there were in the past. Eastbourne, however, did have its fair share of notable visitors.

In the 1830s, Charles Dickens stayed in Borough Lane, Old Town, at the home of his friend, the artist Augustus Egg (a name that sounds like it was invented by Roald Dahl!). A blue plaque now marks the house.

The Poet Laureate Alfred, Lord Tennyson, stayed at a house at the rear of the Cavendish Hotel in 1846. He later returned to stay at the Sea Beach Hotel on the seafront. According to a biography, Eastbourne was his favourite resort, although he chose to move to nearby Seaford in 1851. The Alfriston historian Florence Padgen remembered seeing Tennyson in a broad-brimmed hat and flowing cloak and he was known to the locals as 'the man what makes the potry for the Queen'. One biography mentions that while in Eastbourne he would be seen 'Toiling up the Three Charleses with alpenstock in hand, pipe in mouth and the broadest brimmed of sombreros pulled down over his face so low as to throw it completely in the shade'. He may have been to see the chalk pinnacles known as the Three Charleses at Holywell, but they would have been far too steep to climb.

Charles Darwin lodged at Sea Houses on a number of occasions in the 1850s. He lived at Down House in Kent, but it is said that he wrote his controversial book *On the Origin of Species* while in Eastbourne. This seems unlikely as there would have been too many distractions. In a letter dated July 1853 he says he is in Eastbourne with his wife and seven children 'for the sea-bathing'. The *Origin of Species* was published in 1859 and the following year Darwin returned to Eastbourne for a few weeks – maybe for some peace and quiet.

Above left: Visitors, 1911.

Above right: Alfred Lord Tennyson – photo taken by Charles Dodgson, aka Lewis Carroll.

Revd Charles Dodgson (Lewis Carroll) holidayed in Eastbourne on nineteen occasions, starting in 1877. He lodged at No. 7 Lushington Road and later at No. 2 Bedfordwell Road. On Sundays he attended services at Christ Church. He is, of course, famous as the creator of Alice in Wonderland and the Jabberwocky, but was also a keen photographer. His photos of children have today caused controversy, leading people to question his sexual preferences. He liked to visit the beach and I have found one local reference to him that does not allay those concerns. Apparently, he was fondly remembered in Eastbourne as the 'old gentleman who would carry a stock of safety-pins on him so he could pin up the frocks of girls before they went paddling'.

Frederick Engels was the co-author of *The Communist Manifesto* with his friend Karl Marx. Engels is also a regular visitor to Eastbourne, staying at lodgings at No. 4 Cavendish Place; indeed, it was here that he spent the last few weeks of his life. Following his death in 1895, his ashes were scattered at Beachy Head.

W

Wallpaper

Clement and Mary Brewer moved from London to Sussex in 1901. Clement had fifteen years' experience selling wallpaper, but found a job in Eastbourne working as a clerk for a building company.

Eastbourne was a bustling and growing seaside resort, but there was nowhere to buy wallpaper. At that time wallpaper salesmen would visit the town every few months by train armed with a dozen or so samples of wallpaper to choose from. In those days, plasterwork was much rougher than it is today, and everyone wanted wallpaper to cover their walls – this was particularly the case for the many hotels and guesthouses. Using money from an inheritance, Mary started a business and they rented a shop in Cavendish Place and lived above it with their seven children. Initially the business traded as a 'wallpaper and blind merchant' but the range soon expanded to include paint and decorators' materials.

Clement would order rolls of wallpapers from manufacturers and then cut them up into swatches that could be taken around to clients. For the first time Eastbourne had a large selection of wallpapers and could go to the shop to see samples. In time the premises became too small and they moved to Nos 26 and 28 Pevensey Road. By the 1920s the Brewer sons were able to establish outposts of the company at Redhill and in Tunbridge Wells. By the 1930s Brewers also had shops in Guildford, Horsham, Bexhill and, back in Eastbourne, on Station Parade. To run such a large business a head office was needed, and this opened in Ashford Road in 1934. It remains their headquarters today.

After the war the company expanded across London and the South East and today the company has no less than 177 stores across England. I recently moved into a Victorian house in Eastbourne so there was only one place to get my paint and wallpaper from – Brewers! I'm sure Clement would be happy that his Eastbourne business is thriving over a century after he started the company.

Winter Garden

In 1874, the Duke of Devonshire announced that he was determined to erect a number of buildings in his 'new park' – Devonshire Park. As well as swimming baths he was

WINTER GARDENS, EASTBOURNE L 300

The Winter
Garden.

going to build a library, skating rink and 'winter garden'. There was also talk of an aquarium. Winter gardens were essentially large greenhouses and were inspired by the one built at Buxton. They proved to be very popular at many resorts across the country. They allowed visitors to 'parade' when the weather was inclement.

Built of iron, glass and zinc, the Winter Garden was described shortly after it was opened in 1875 as being a 'Miniature Crystal Palace'. It was designed by Henry Currey, who also designed the Queens Hotel. A roller-skating rink here was run by an American, John Calvin Plimpton, and on sunny days the doors of the building were opened so that skaters could skate right in!

Today the Winter Gardens consist of two large halls: the Floral Hall and the Gold Room. However, the elegant lines of its design were rather spoiled in 1910 when they were hidden behind a new entrance. The building today is used for concerts, dances dinners and conferences.

Wish Tower

The Wish Tower is perhaps the best placed of all of the Martello towers on the south-east coast. Built on a small hill, it commands an excellent view of the coast between Beachy Head and the Redoubt. It is built on just over 2 acres of land close to a low marshy area (now Devonshire Park) that was once called The Wash or Wish; indeed, it is probable that this area was once a small harbour. The ground was built up around the base of the tower to form a dry moat, which now contains a war memorial to the civilians killed in the many air raids of the Second World War (see page 6).

The cannon, which was once on the roof, probably never fired a shot in anger and between 1812 and 1860 the tower was a base for the local coastguard. Since then it has been a geological museum, a military museum and even a puppet museum.

The interior remains a secret for many, but the Friends of the Wish Tower do arrange regular tours, which are fascinating. The view from the roof is the best to be had in Eastbourne. Check their website for details.

Cross

Eastbourne has a poor, lost and overlooked refugee. Hidden behind a noticeboard in the churchyard of St Mary's Church, is an unusual but brilliantly decorated Cornish cross. The cross was kidnapped from its home and brought to Sussex over 200 years ago.

The culprit was Davies Giddy, who lived at Tredrea, St Erth, near Hayle in Cornwall, and was the curate of St Erth Church. Born in 1767, he had an interest in astronomy, mathematics and engineering and his friends included Humphrey Davy, Thomas Telford and Richard Trevithic. He was interested in using steam power to run railway trains.

Giddy became the High Sheriff of Cornwall and served as the MP for Bodmin from 1806 until 1832. He fell in love with Mary Jane Gilbert, the only child of the family who owned the Manor House in Eastbourne. After they married on 18 April 1808 he agreed to take her name. They lived at the Manor House in Eastbourne, in Cornwall and in London, where he stayed to be close to Parliament.

Gilbert was a keen geologist and antiquarian, and was particularly interested in the history of Cornwall. He wrote a four-volume history of the county and even wrote books in the Cornish language. He was the president of the prestigious Royal Society in London.

With this background it is surprising that he chose to uproot a symbol of ancient Cornwall and move it to Sussex. Gilbert had noticed an old Cornish cross just off the road between Truro and Redruth in the parish of Kenwyn. The large cross, around 8 feet tall, was being used as a gatepost. He thought that the ancient relic needed to be rescued and originally was going to take it to his home in Tredrea. His relative John Giddy arranged with the farmer for the removal of the cross and for a proper gatepost to be built in its place.

The cross was probably taken to Tredrea where Gilbert changed his mind and decided that it would be better to re-erect it 300 miles away at his new home in Eastbourne. The cross was taken to London by road and then sent by sea to Hastings and it finished its trip by road again.

On 10 December 1817 Colonel Ellicomb of the Royal Engineers assisted Gilbert in erecting the cross in the grounds of the Manor House (now Manor Gardens) by using

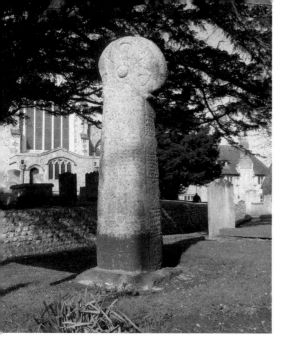

Left: Eastbourne's Cornish cross.

Below: Arthur Langdon's drawings.

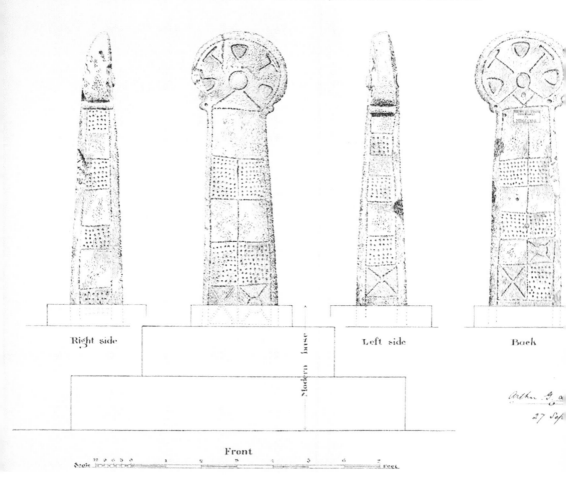

Ancient Cornish cross, In the Manor House Grounds, Eastbourne. Sussex.

Right side

Left side

Back

Modern base

Front

Scale

Feet

an 'Artillery Triangle Fall Block'. Sadly, it is likely that this wonderful cross was seen by less people than when it was beside the road near Truro.

Giddy was once asked by a Cornish friend, Revd-Canon Hockin of Phillack, why he had taken the stone from Cornwall. He replied that the poor ignorant folk of Sussex needed to be shown that there was something better in the world than flint. The vicar replied, 'We are robbed!'

The stone stood behind the walls of the Manor House for many years and in 1890 the Cornish historian Arthur Langdon visited Eastbourne to inspect the stone. He was writing a book on Cornish crosses and although he had listed and illustrated dozens of examples thought that the one at Eastbourne was particularly good. He made a detailed report that included fine drawings. He said that there were only seven of a similar design, but the Eastbourne cross was the most ornate of all. He records that the cross was 8 feet 2 inches tall and made of elvan, a hard granite-like Cornish stone. As for a date, Langdon says the cross is 'early', but it has been since dated to the tenth century.

In July 1895, the Sussex Archaeological Society visited Eastbourne as guests of the Duke of Devonshire. They visited the Town Hall, St Mary's Church and the cellars under the Lamb Inn. They then went to inspect the Cornish cross in the Manor Gardens. It seems that a short time later, and certainly by 1902, the cross was removed to the eastern end of St Mary's Churchyard, very close to the Lamb Inn.

But what of the cross today? It is still in a good condition, although sadly it is hidden behind the church noticeboard so is no longer really visible from the road. Have a look at it next time you are at the church or having a pint in the Lamb. Maybe it would be better if it was returned to its home in Cornwall where I believe it will be appreciated much more than in Eastbourne.

Yachts

Thursday morning is a good time to visit the lake at Princes Park as you will have a good chance of seeing model yachts skimming across the water. The Eastbourne & District Model Yacht Club practice there most Thursday mornings.

On the side of the pond a number of gentlemen use radio controllers and I first thought that the yachts were powered by an engine, but this is not the case. The controllers only move the sails and rudder – wind provides the forward motion. Chatting to the friendly members, it is clear how committed they are to their hobby. I was told most of the members were older gentlemen (there is currently one female member) who were no longer able to race full-sized yachts. Members keep their prized models in the nearby tidy boathouse, the walls covered with reminders of competitions won. One plaque recalls club member Trevor Binks, who won the world championship for 1-metre yachts in Vancouver in 2003.

An Eastbourne Model Yacht Club was established in May 1879 at the Rowing Club boathouse at Seaside. The first model yacht race was held on Whit Monday 1879 at the brickfield pond near the Archery Pub. The first commodore of the club was Mr Arthur Bond Wrangham, a former captain in the Sussex Artillery Volunteers who was also the master of the Eastbourne Harriers (foxhounds).

It seems that the club ran out of wind as there are no further mentions of it in the local press for many years. In January 1901 there was a model yacht race at the pond near the fishing station. There were just ten entries; however, the following month there was another race with more yachts competing. Model yachtsmen wanted to race on the lake at Hampden Park, but this was stopped by the council as it was thought that the yachts would interfere with wildlife. It is clear that there was a need for a suitable venue for model yacht racing.

Carew Davies Gilbert was the Lord of the Manor of Eastbourne and in 1905 he gifted land between the Archery and the Crumbles with a view to creating a recreation ground with a large pond that could be used for model yachts. The council agreed to the scheme saying that it would provide work for unemployed men during the winter months. It took years for the recreation ground to be laid out and the old Crumbles

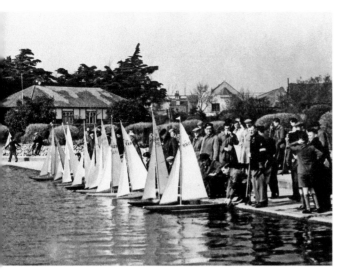

Above left: A model yacht race at Princes Park.

Above right: Racing today.

pond to be re-excavated and lined with much of the work done by men who had returned to Eastbourne from the horrors of the trenches.

It seems that the pond was ready for model yacht racing by the spring of 1928, the Eastbourne and District Model Yacht Club was established at the same time. On Saturday 26 May 1928, the mayor of Eastbourne, Councillor Alice Hudson, officially opened the Model Yacht Club at the Gilbert Recreation Ground, which was followed by a regatta. The chairman of the new club was Mr H. B. Tucker, who according to the *Eastbourne Gazette* was 'recognised as an authority on model yachts both in Great Britain and in the Colonies'.

In June 1931 the Prince of Wales planted an oak tree at the nearby recreation ground and the area was renamed Princes Park after him; however, the lake is still officially called the Gilbert Lake, although the name is rarely used today.

When I was young I loved to watch the yachts on the lake and sometimes got to splash across the water on a pedalo. I never realised that the lake was actually designed for model yachts; indeed, each end of the lake has a straight section with lower pathways specifically designed for model yacht racing and you can see the fittings which once held a pennant to mark the starting place of each yacht during races. A visit to the lake and the nearby Boathouse Café, where they serve good coffee and delicious cake is highly recommended.

Zeppelins

The Zeppelin was a real worry to the people of Eastbourne during the early years of the First World War. These cigar-shaped airships had been invented in Germany by Count Von Zeppelin, the first taking to the skies over Lake Constance in 1900. (The *Eastbourne Gazette* described it as a 'wonderful flying machine'.) But this excitement soon turned to fear. At the start of the war the enemy had just seven airships, but they were quickly developed and more were built by the German Navy. By late 1914 they were regularly seen along the east coast of England. These were reconnaissance flights but soon the airships were being used for air raids.

In October 1914, Major Brannigan of Selwyn Road, Eastbourne, was in Antwerp in Belgium when it was bombed by Zeppelins. He sent a part of a Zeppelin shell back to Eastbourne as a souvenir. This was an omen of things to come. In January 1915 Zeppelins bombed the towns of Kings Lynn, Sheringham and Great Yarmouth. Four people were killed. This must have caused panic in all south coast coastal towns. In January 1915 Eastbourne authorities imposed strict lighting orders on the town and there was a suggestion that the town may even have an anti-aircraft gun.

In June 1915 a letter to the *Eastbourne Gazette* warned of a German plan of invasion using 'aerial fleets comprising of one zeppelin and four aircraft' attacking England via the south coast. The correspondent thought that the town was likely to be attacked and finished his letter 'Wake Up Eastbourne!'

In August 1915, Major Teale, the chief constable of the Eastbourne Borough Police, received information that that the town was to be attacked by Zeppelins on the night of Tuesday 17 August and the whole town lay in darkness. There was a scare at 10.35 p.m., but the anticipated air raid did not materialise.

Every week dozens of people were summonsed for showing lights in contravention of the Lighting Orders – some were locals, but many were visitors failing to close their hotel bedroom curtains. There were complaints that the law was enforced more strictly in Eastbourne than in other coastal resorts, which was especially ironic considering that the bright light of Beachy Head Lighthouse continued to flash its warning miles across the channel.

By March 1916 the chief constable of the East Sussex Police admitted that the probability of a Zeppelin raid was remote. Although the lighting restrictions remained until the Armistice there were no Zeppelin attacks on Eastbourne.

Right: Eastbourne Lighting Order.

Below: A Zeppelin.

COUNTY BOROUGH OF EASTBOURNE.

Order as to Lights.

The MILITARY AUTHORITIES
have ordered that

ALL LIGHTS

other than those not visible from the outside of any house, or navigationable lights, are

TO BE EXTINGUISHED

in Eastbourne, between the hours of

5 P.M. AND 7.30 A.M.,

from TO-DAY and until further Orders, **and this is strictly to be carried out by the inhabitants.**

ANY PERSON FAILING TO COMPLY WITH THIS ORDER WILL BE INEVITABLY ARRESTED.

EDW. J. J. TEALE (Major),
Chief Constable.

CHIEF CONSTABLE'S OFFICE,
TOWN HALL, EASTBOURNE.
26th January, 1915.

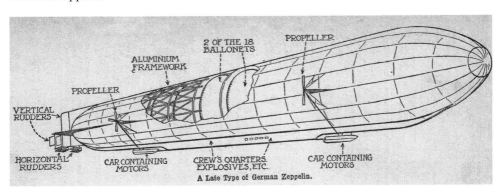

A Late Type of German Zeppelin.

Sources and Acknowledgements

Thank you to Andy Hatchard for the Eastbourne alphabet postcard. Thanks to Jim Butland and Paul Dixon, the enthusiastic engineer of Eastbourne Pier, who allowed me a rare visit to the camera obscura, and Jenny Murray for showing me around the ancient Langney Priory. Thank you to Lloyd Stebbings and Allchorne Marine for access to their boat shed and the *Duke of Kent* lifeboat Thanks also to the friendly members of the Eastbourne and District Model Yacht Club. Members of the Eastbourne History Society are thanked, particularly its chairman, Russell Owen, for assisting with several photos. As ever, my wonderful wife Mandy has provided support and corrected my spelling.

I have used a variety of sources for this book, including *Pevsner's Buildings of East Sussex* and the 'Eastbourne Historic Character Assessment Report' (published in 2008). I have also made extensive use of the National Newspaper Archives, focussing on old copies of the *Eastbourne Gazette* and *Eastbourne Herald*.

Useful Websites

Eastbourne History Society: www.eastbournehistory.org
Eastbourne Society: www.eastbournesociety.co.uk
Heritage Eastbourne: www.heritageeastbourne.co.uk
Eastbourne & District Model Yacht Club: edmyc.org.uk
Eastbourne Bonfire Society: www.eastbournebonfiresociety.com
Eastbourne Theatre History: www.arthurlloyd.co.uk
Allchorne Martime Heritage: www.allchornpleasureboattrust.org.uk
Local Shipwrecks: www.sussexshipwrecks.co.uk

If you enjoy local history why not visit my website: www.sussexhistory.net.